NEW YORK

THEN AND NOW®
People and Places

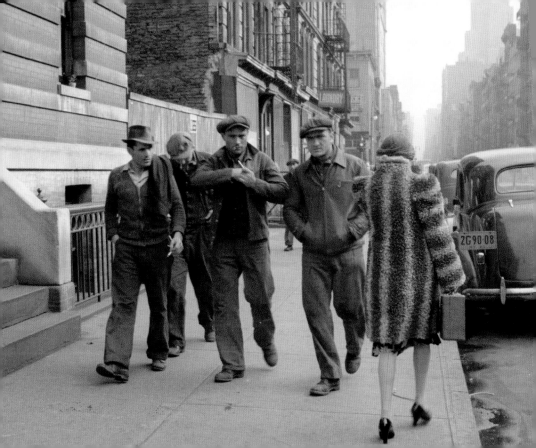

NEW YORK
CITY AND STATE

THEN AND NOW®
People and Places

First published in the United Kingdom in 2013 by
PAVILION BOOKS
10 Southcombe Street, London W14 0RA
An imprint of Anova Books Company Ltd

ISBN: 978-1-86205-995-5

A CIP catalogue record for this book is available from the British Library.

Printed by 1010 Printing International Limited, China.

10 9 8 7 6 5 4 3 2 1

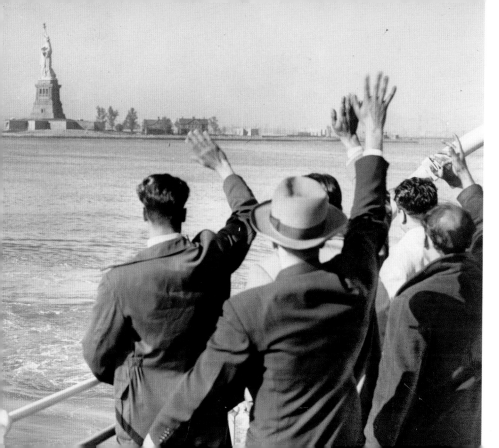

The Statue of Liberty, 1952

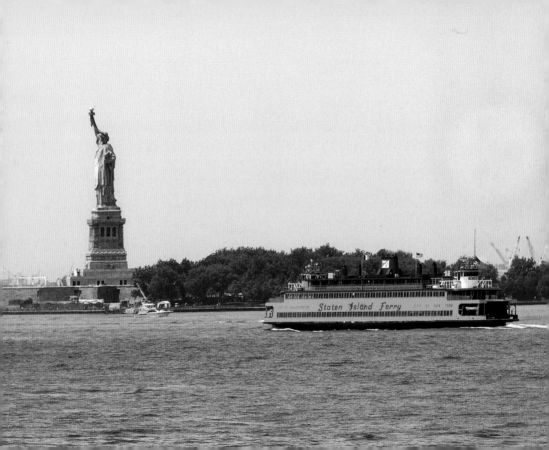

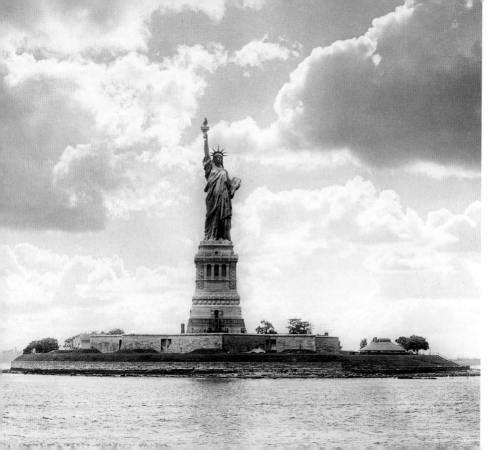

The Statue of Liberty, 1905

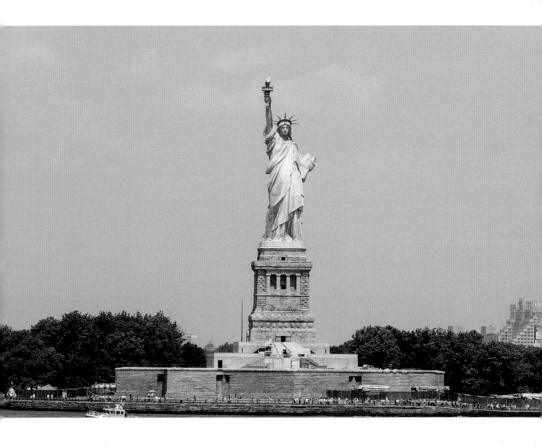

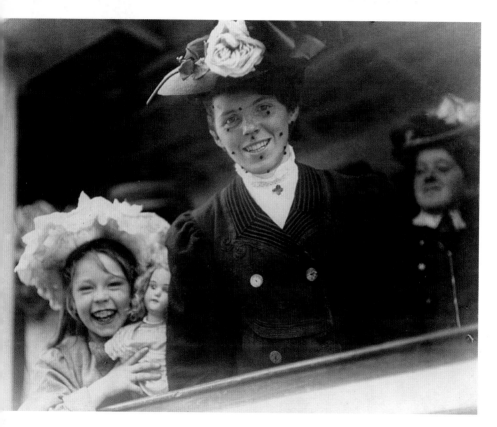

Arriving at Ellis Island, c. 1910

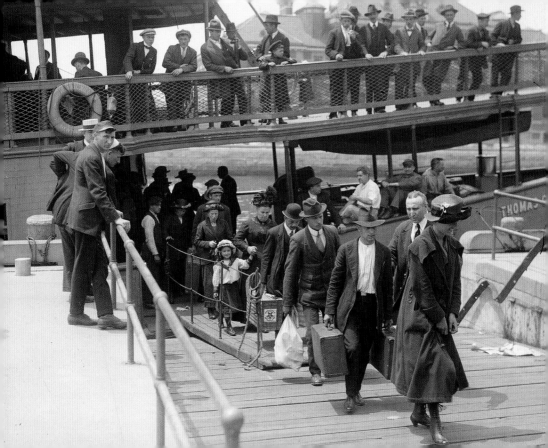

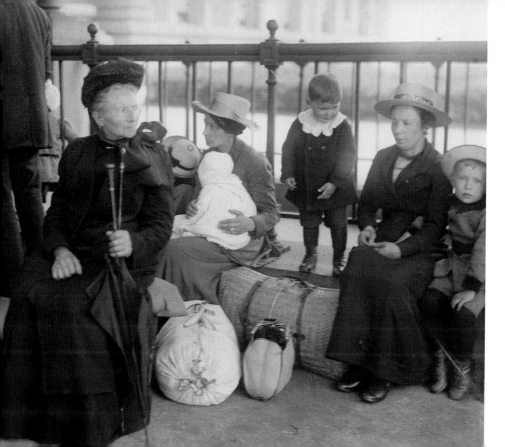

Ellis Island, c. 1915

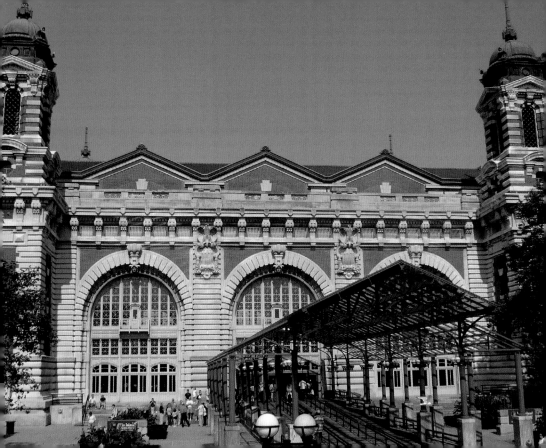

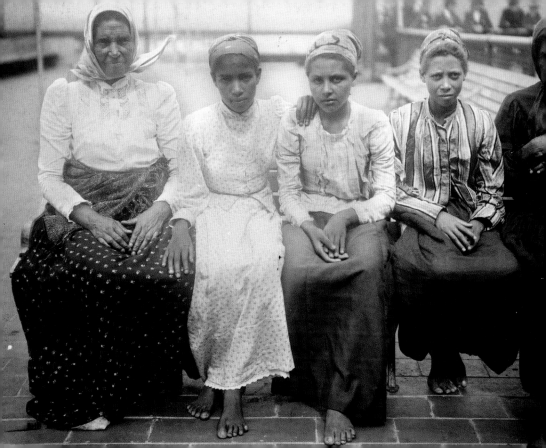

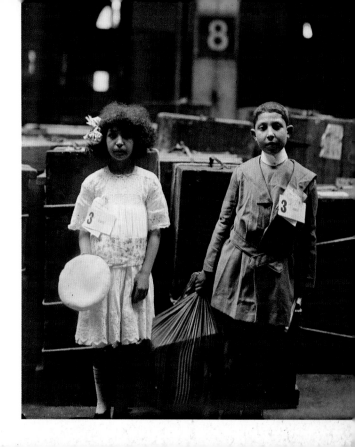

Ellis Island, c. 1910

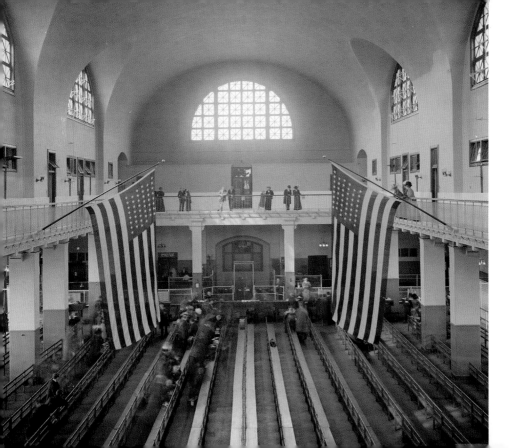

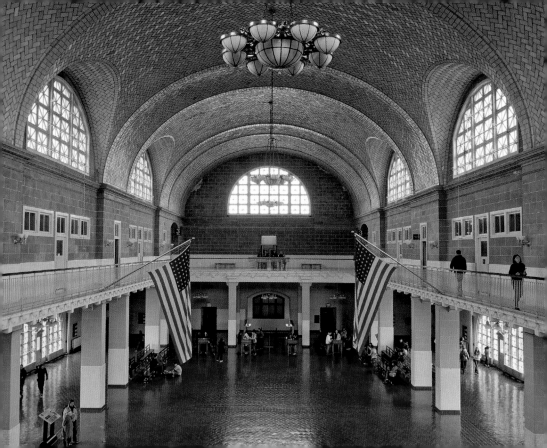

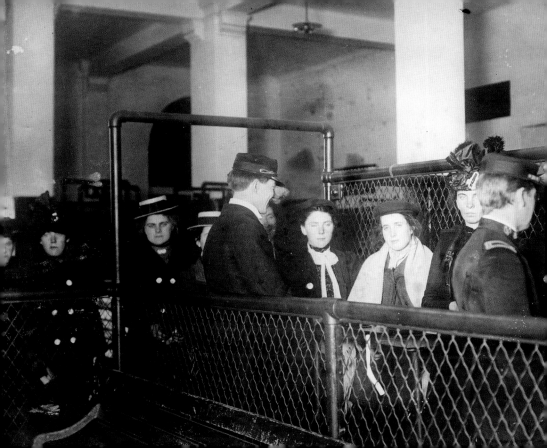

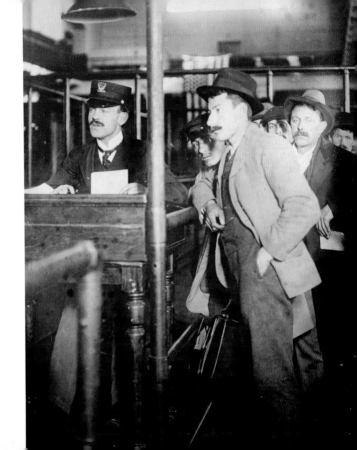

Ellis Island, c. 1910

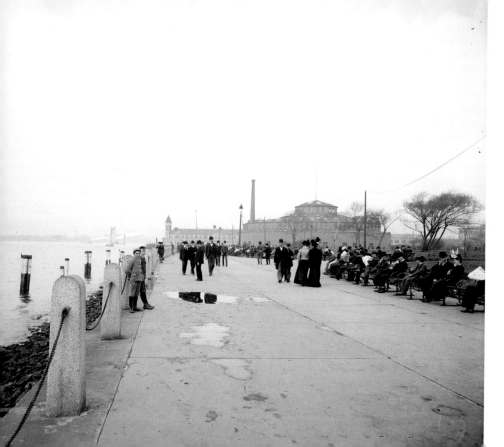

Battery Park, c. 1905

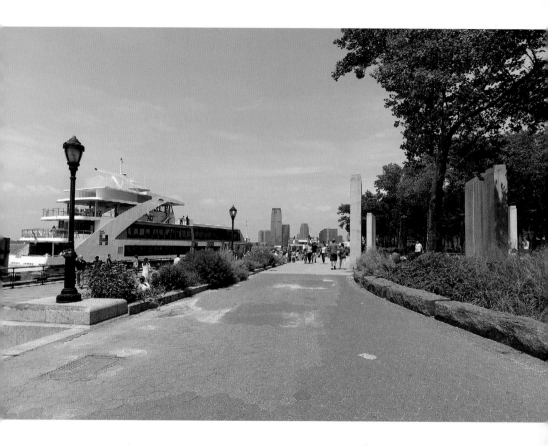

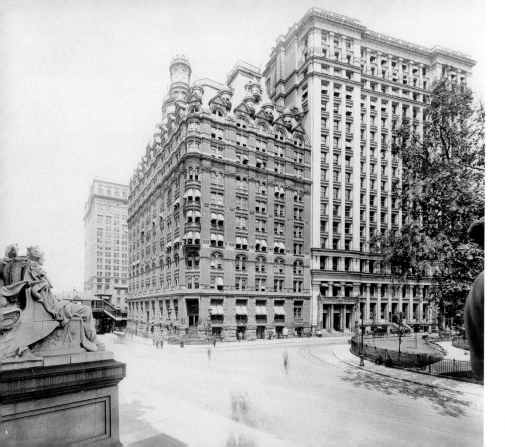

Broadway and Battery Place from Bowling Green, 1908

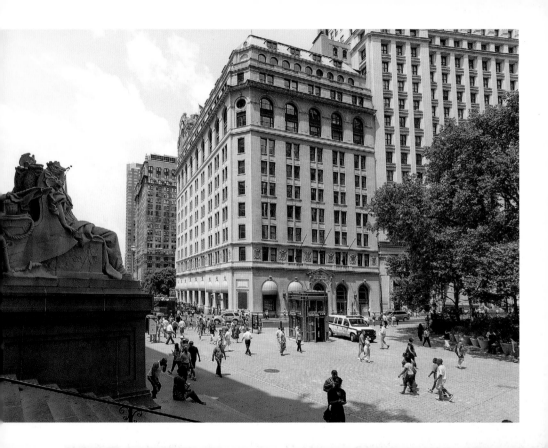

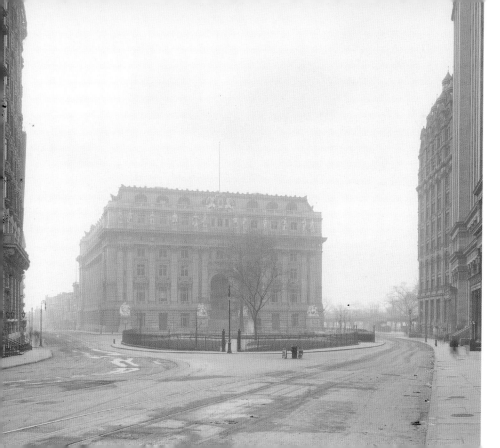

Custom House, Bowling Green, 1908

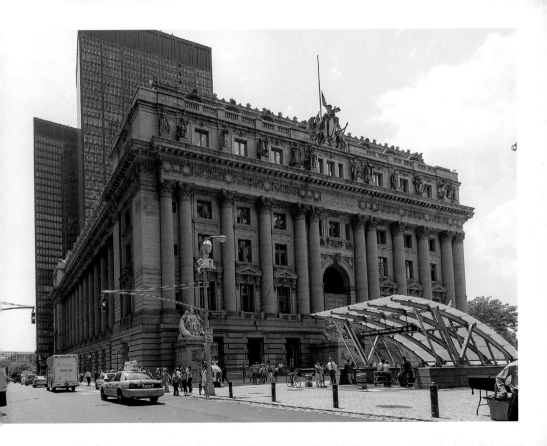

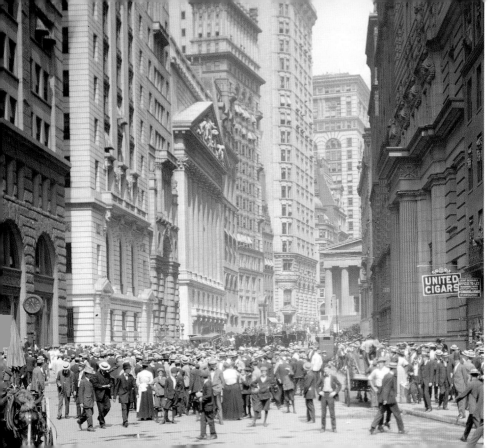

New York Stock Exchange, Broad Street, c. 1910

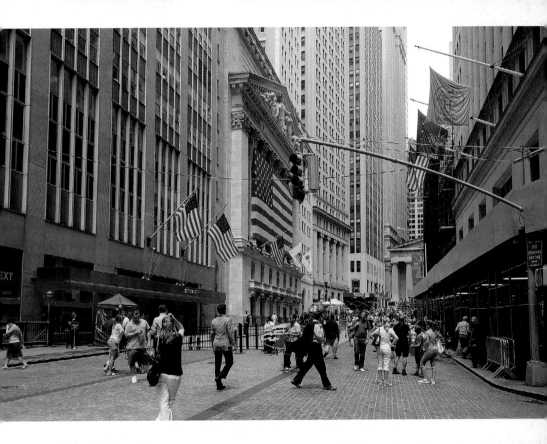

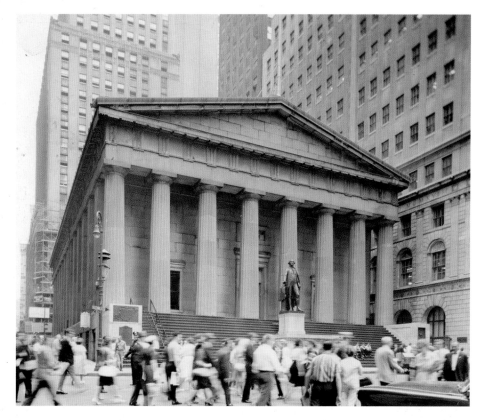

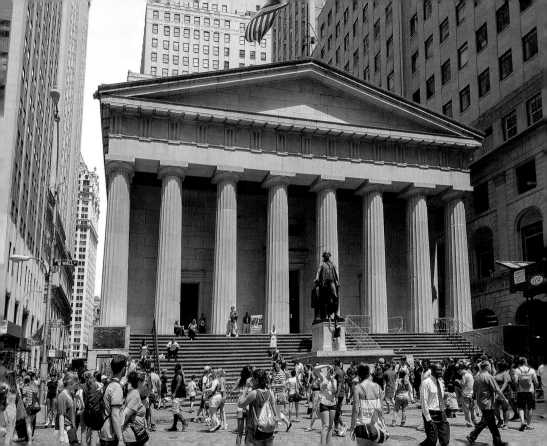

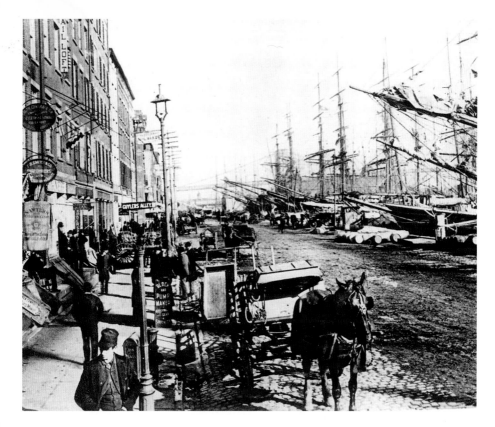

South Street Seaport, c. 1890

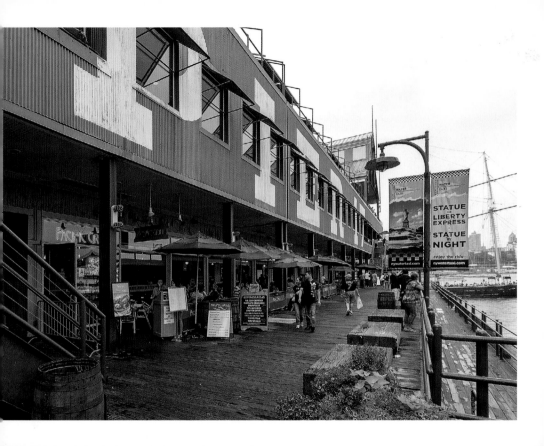

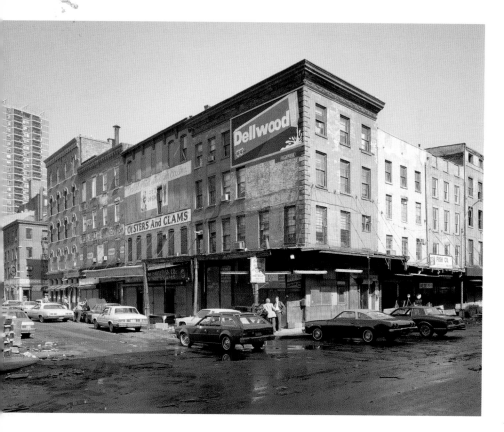

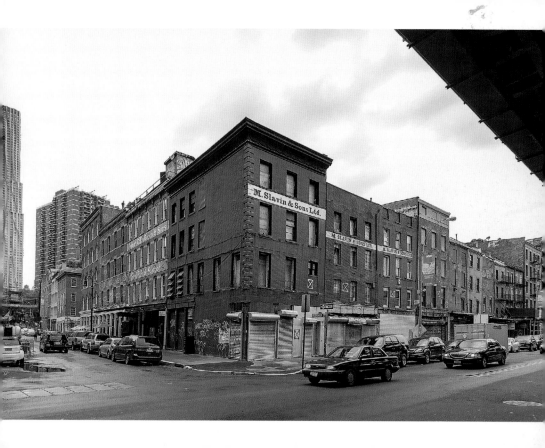

World Trade Center, 1999

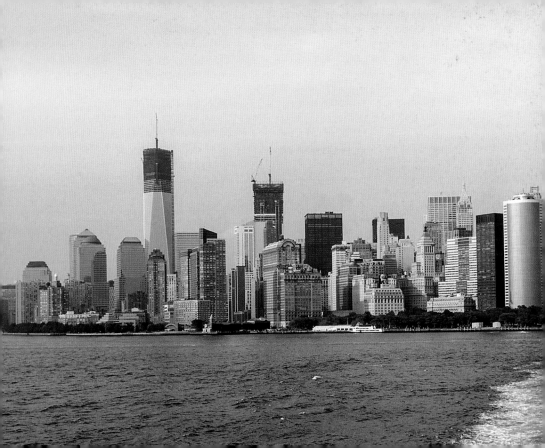

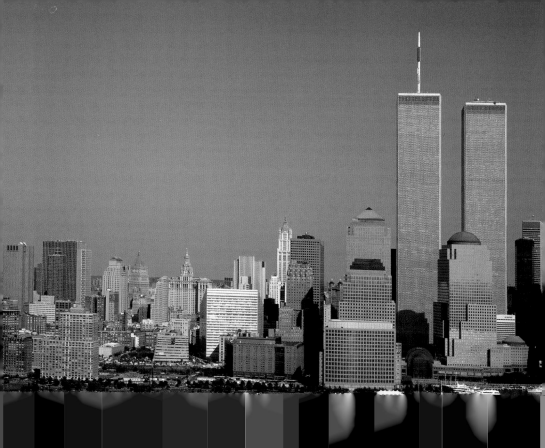

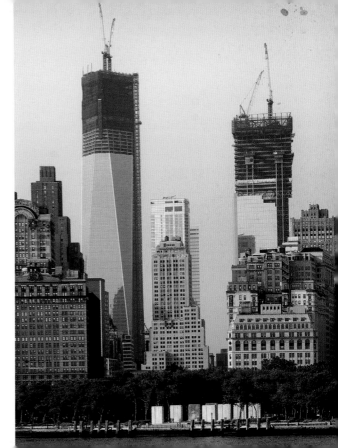

World Trade Center, 1999

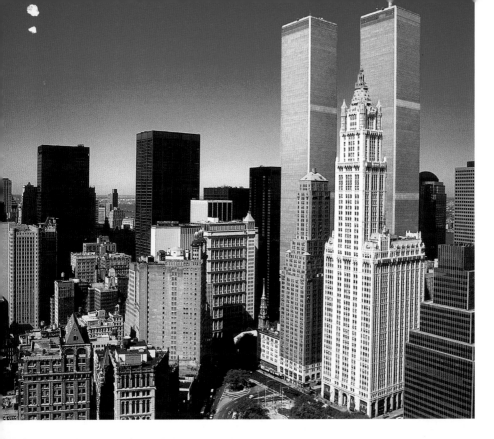

Transportation and Woolworth Buildings, 1999 (left), 1939 (right)

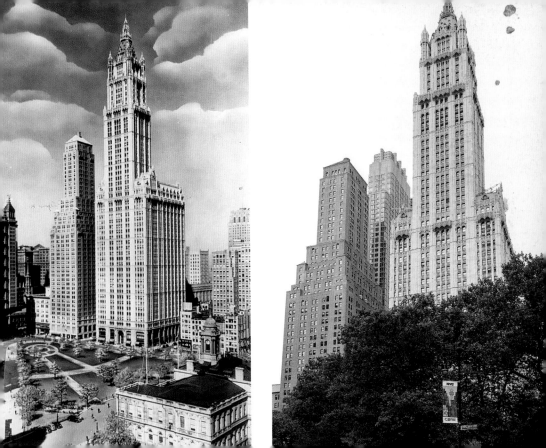

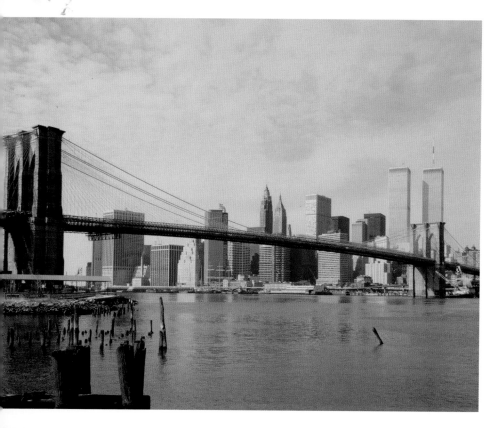

Brooklyn Bridge, 1982

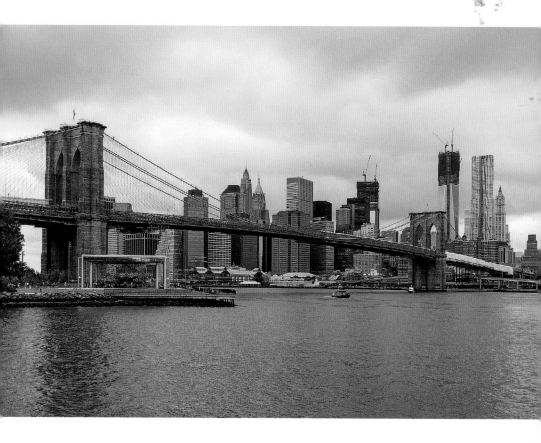

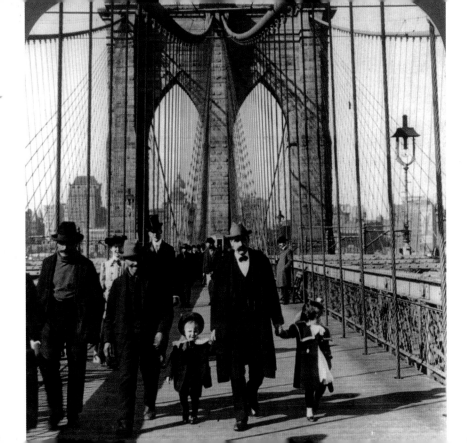

Brooklyn Bridge, 1904

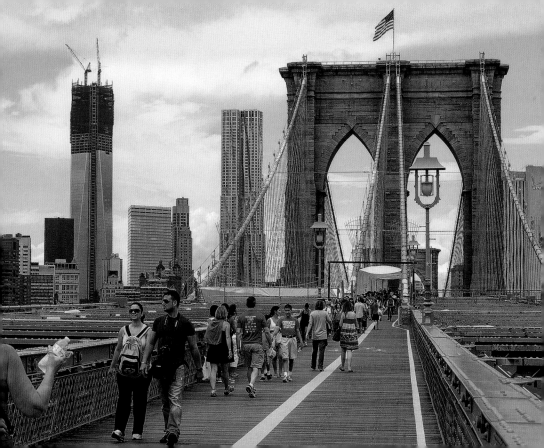

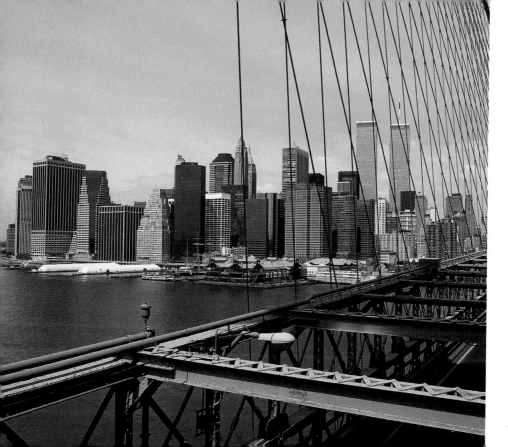

Brooklyn Bridge, 1999

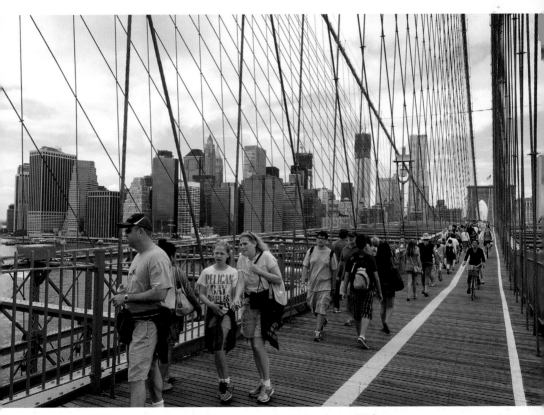

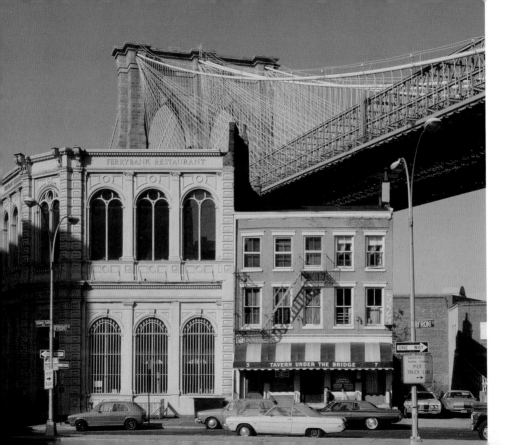

Brooklyn Bridge from Front Street, 1982

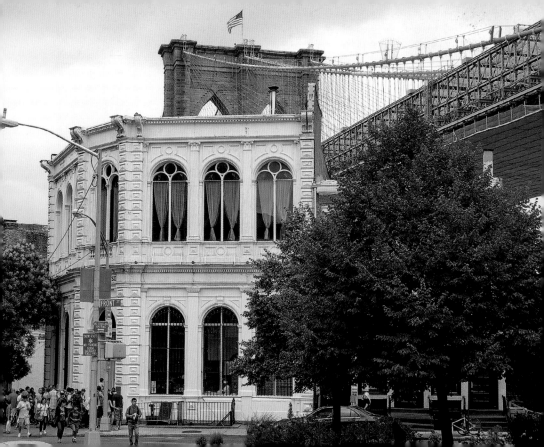

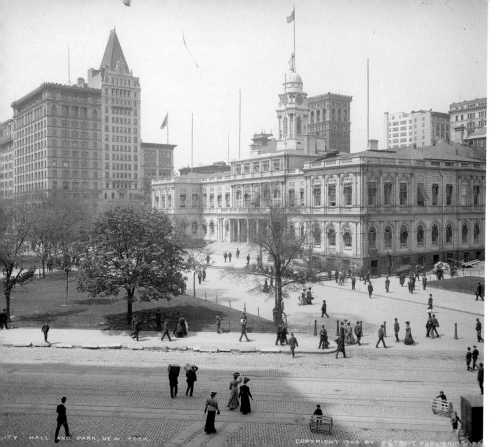

City Hall, 1905

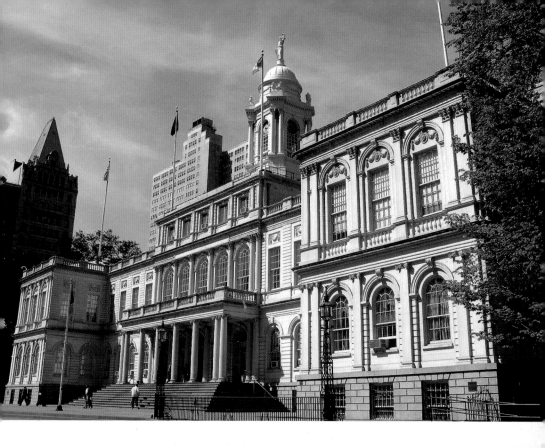

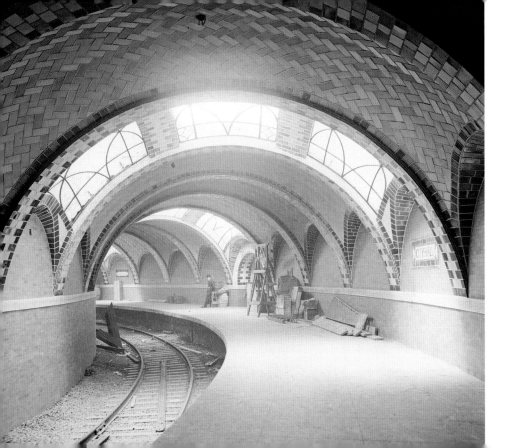

City Hall Subway Station, c. 1905

50

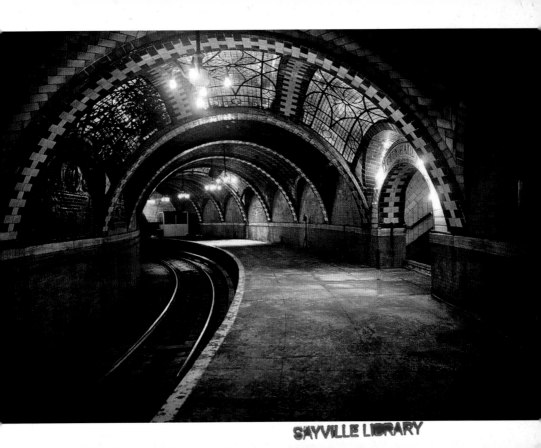

SAYVILLE LIBRARY

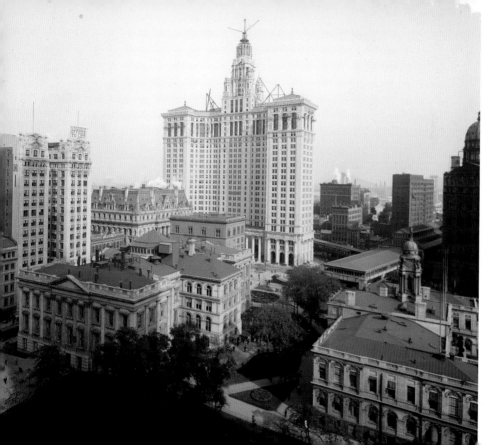

Manhattan Municipal Building, 1914

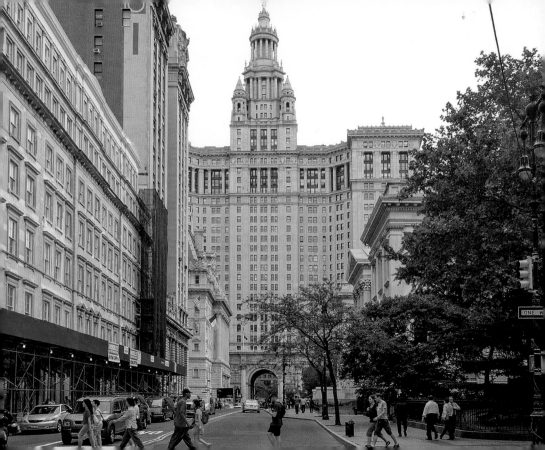

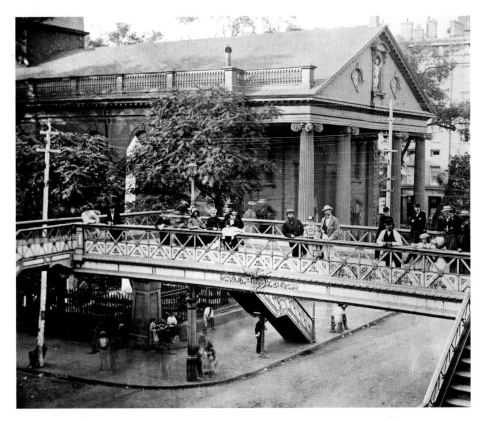

St Paul's Chapel, c. 1890

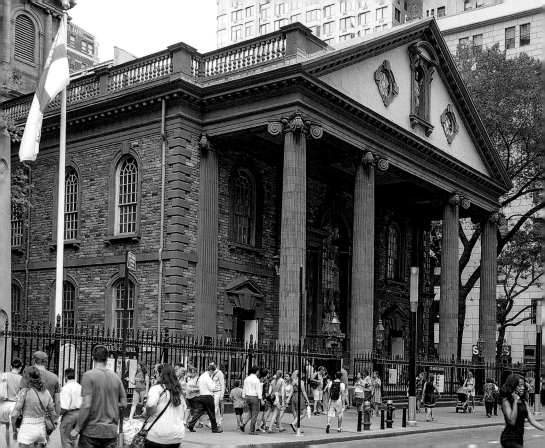

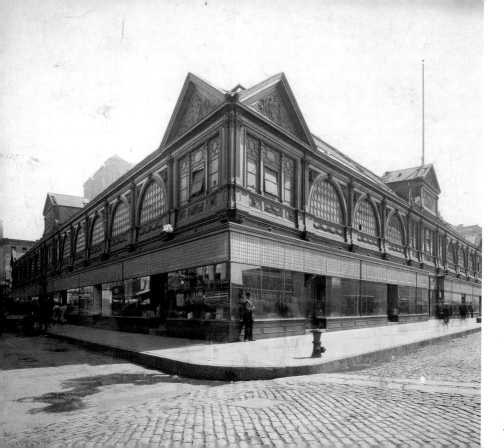

Washington Market at Warren and Greenwich Streets, c. 1912

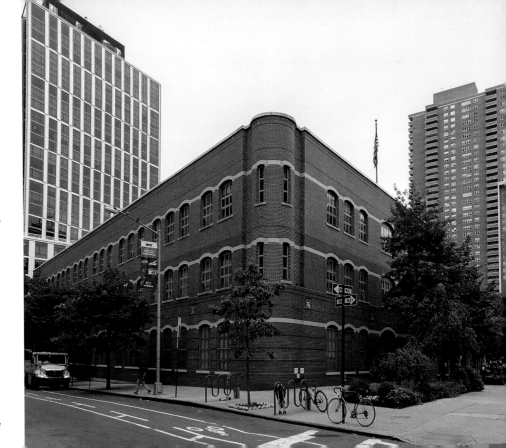

P.S. 234, The Independence School

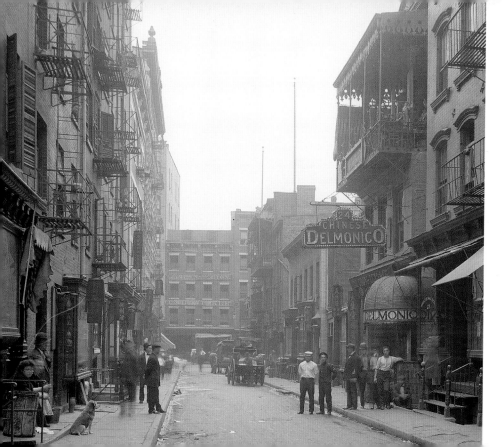

Pell Street, Chinatown, c. 1910

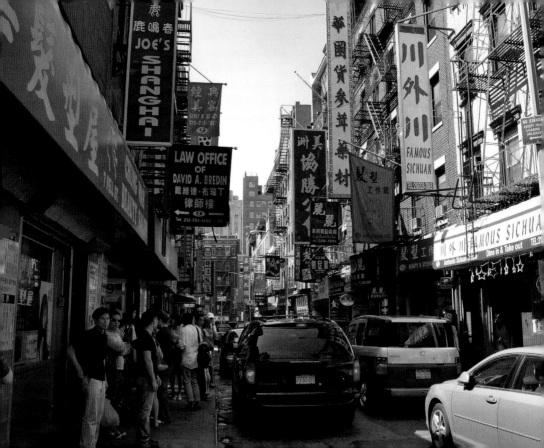

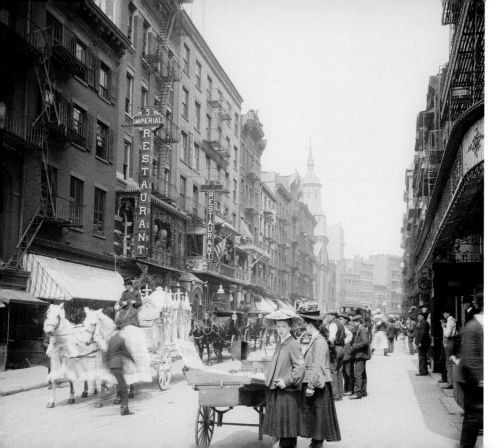

Mott Street, Chinatown, c. 1910

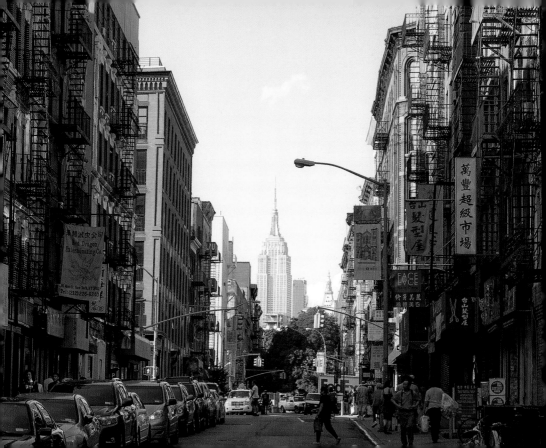

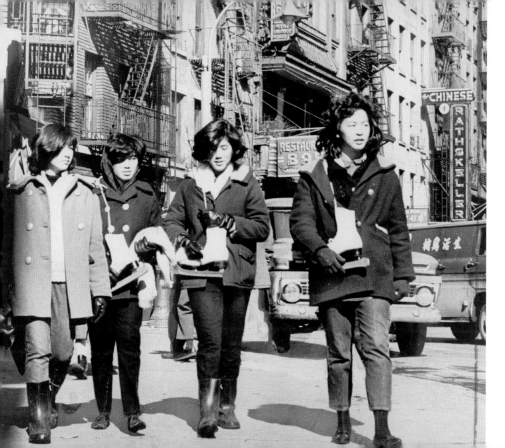

Mott Street, Chinatown, 1965

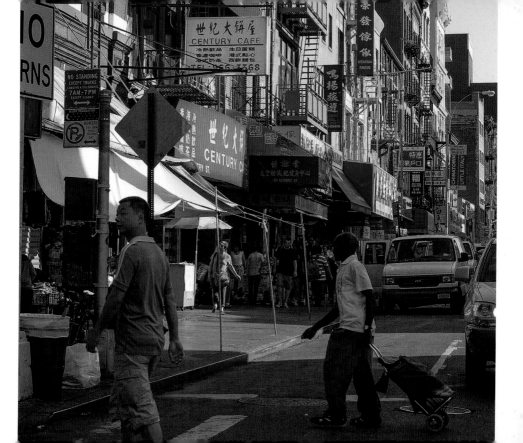

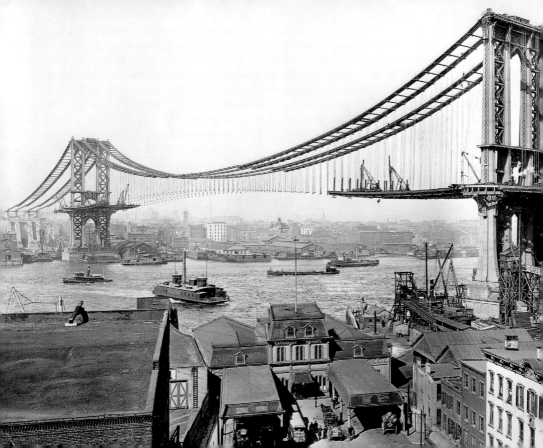

Manhattan Bridge under construction, 1909

65

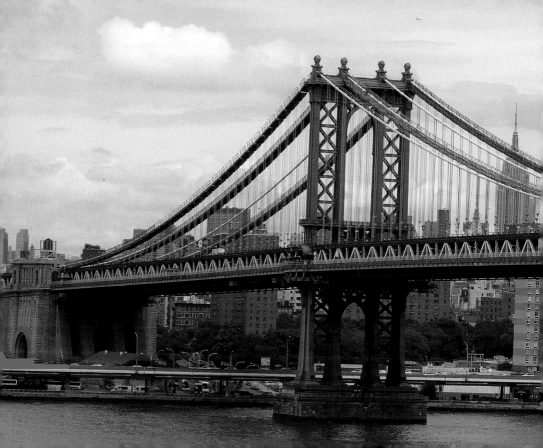

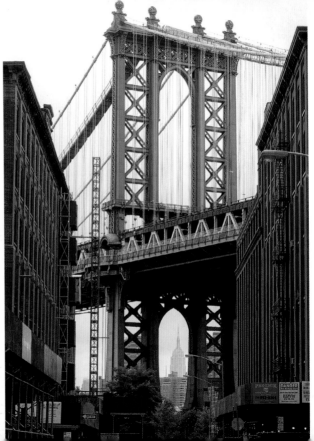

Manhattan Bridge

67

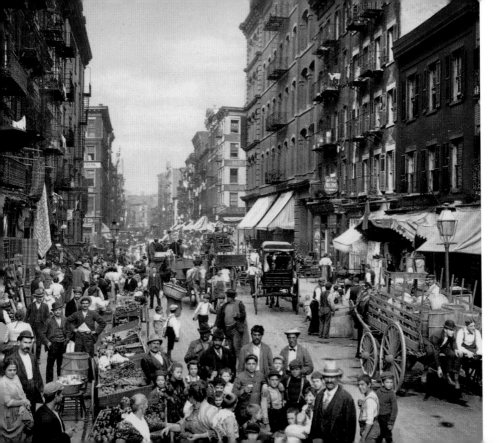

Mulberry Street, Little Italy, c. 1900

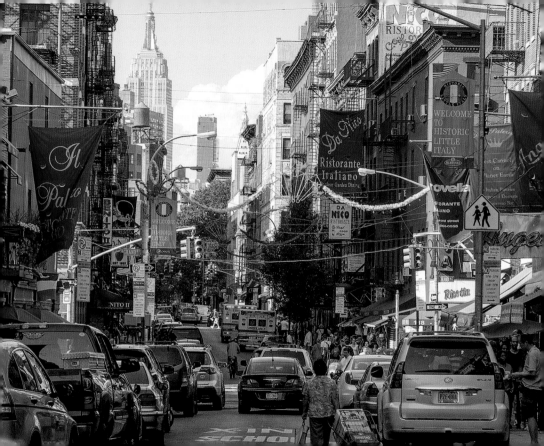

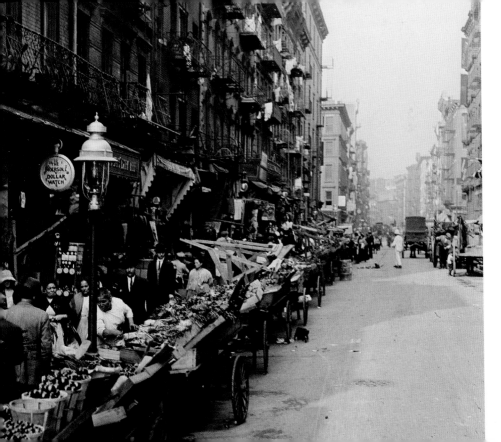

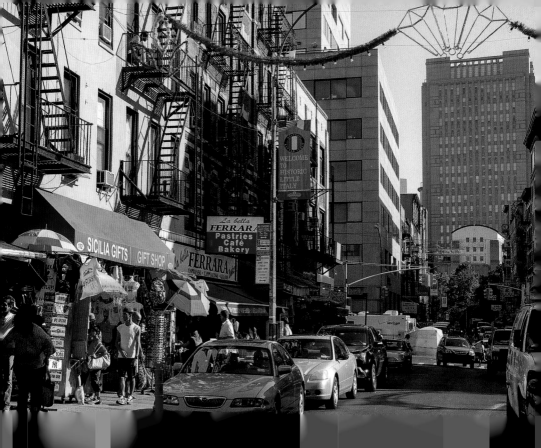

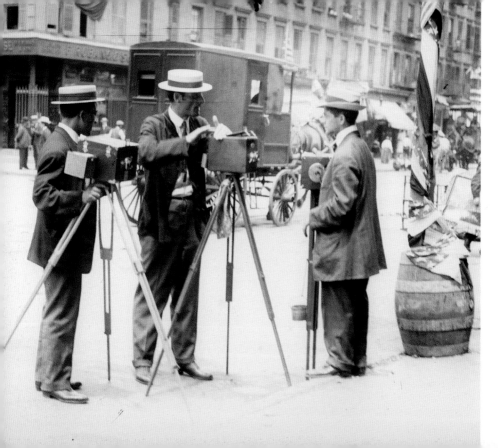

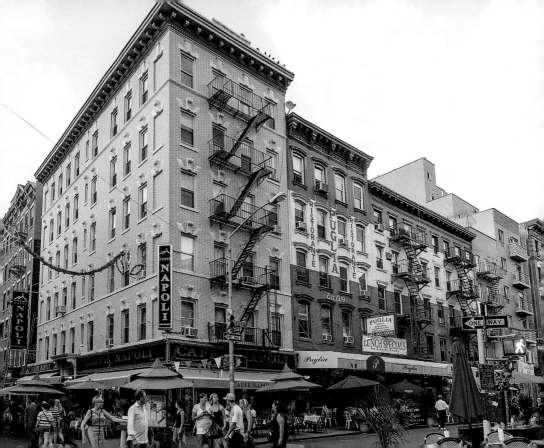

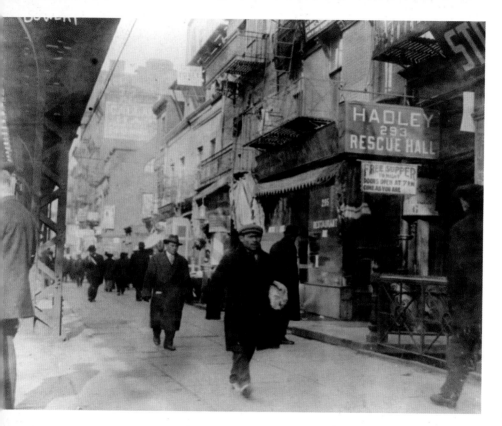

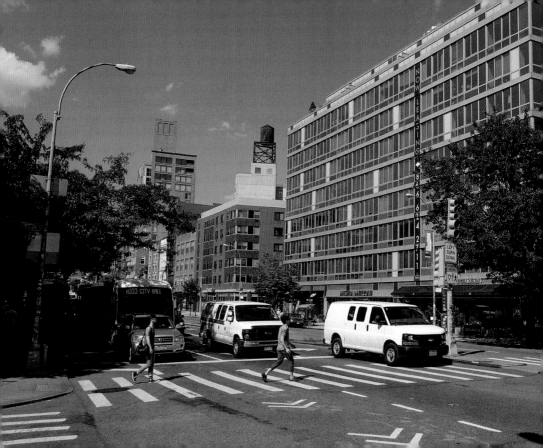

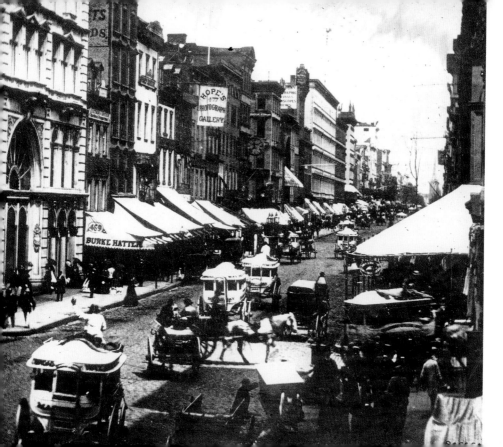

Broadway at Grand Street, 1860

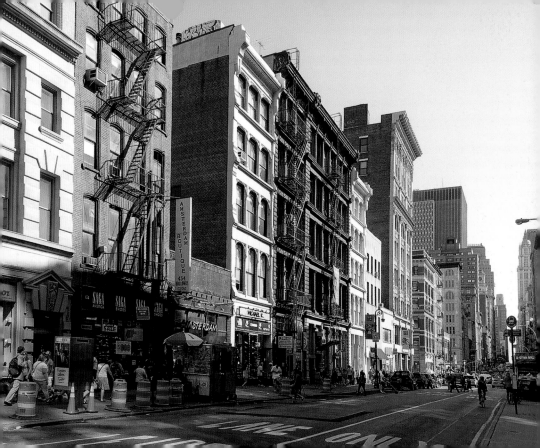

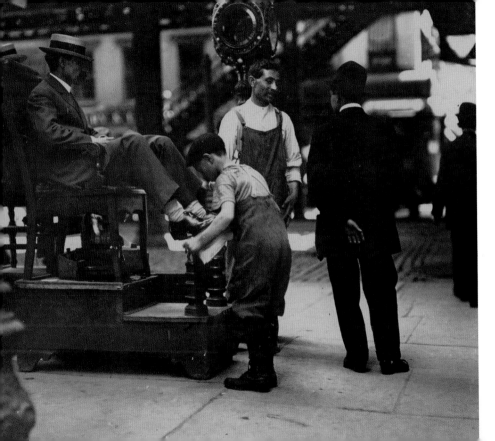

Third Avenue and Ninth Street, 1910

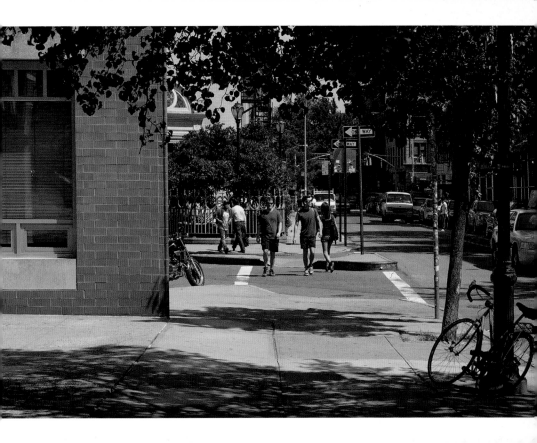

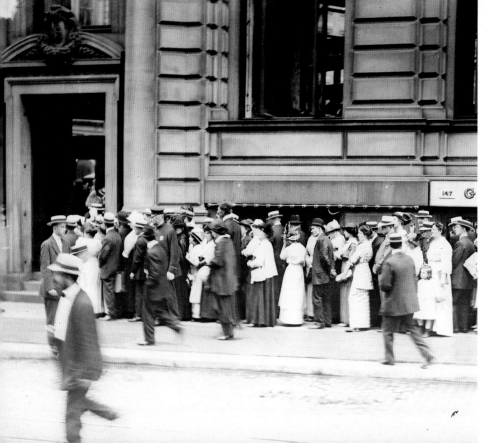

Run on German Bank, 147 Fourth Avenue, 1914

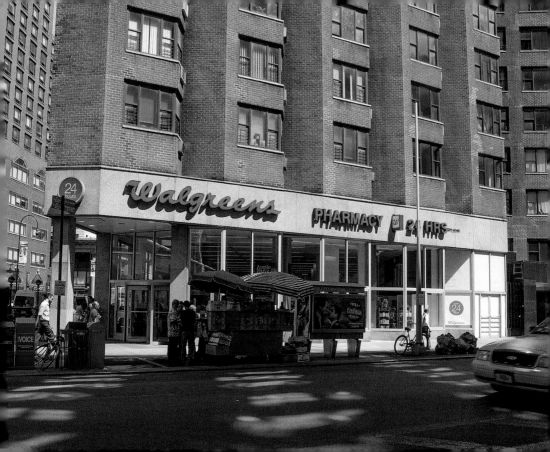

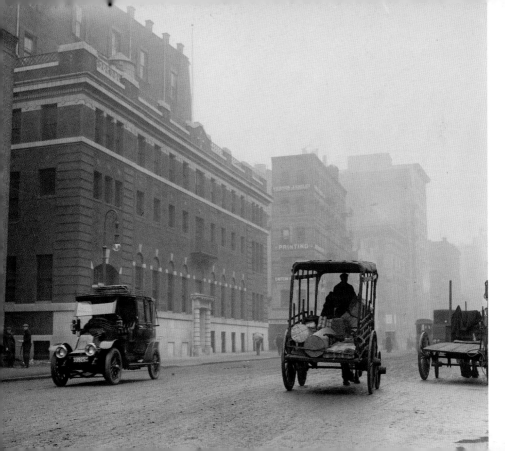

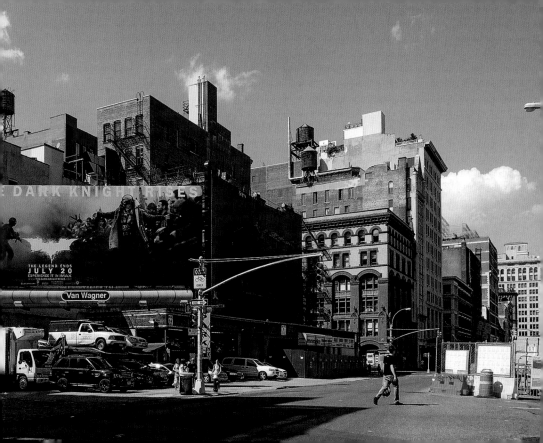

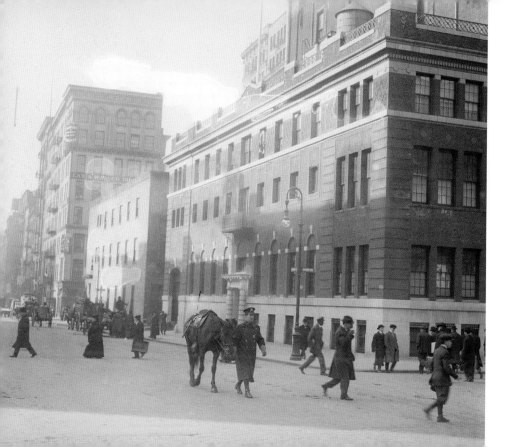

Lafayette Street, 1914

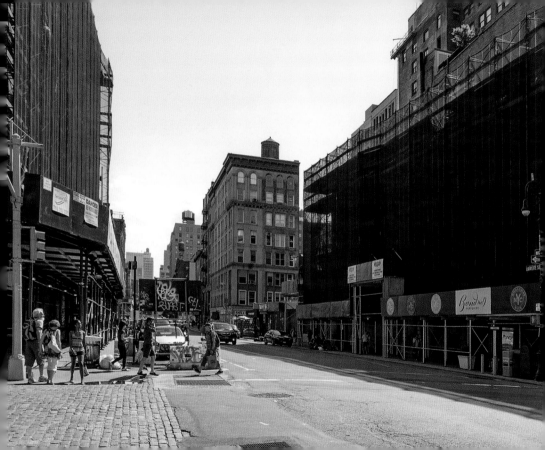

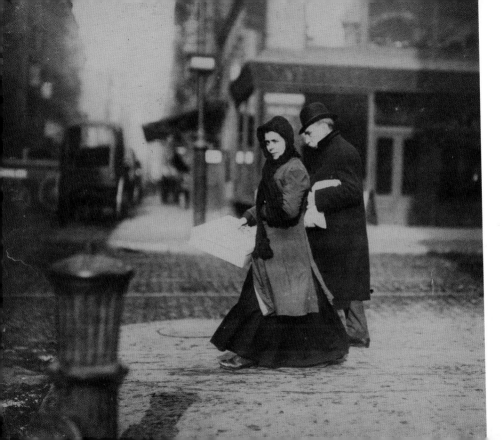

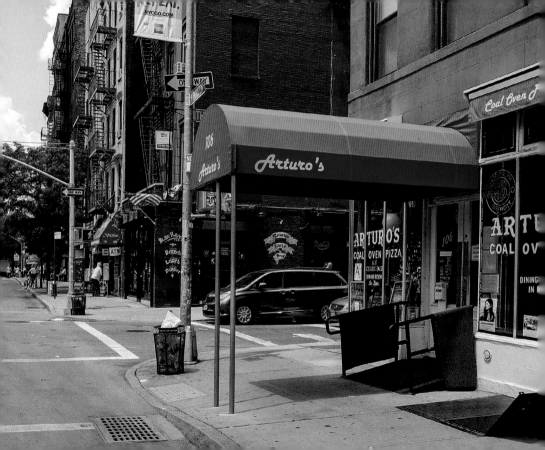

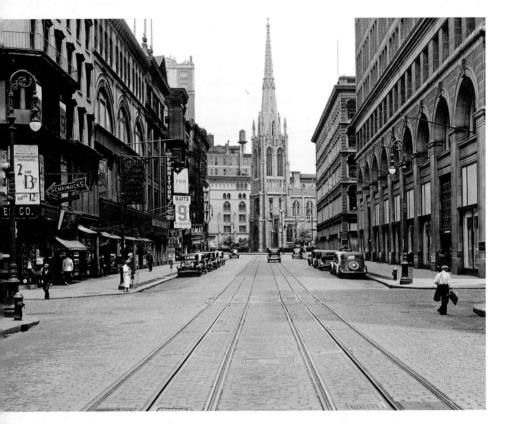

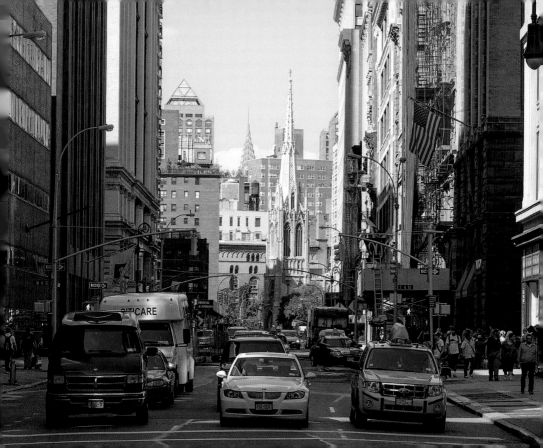

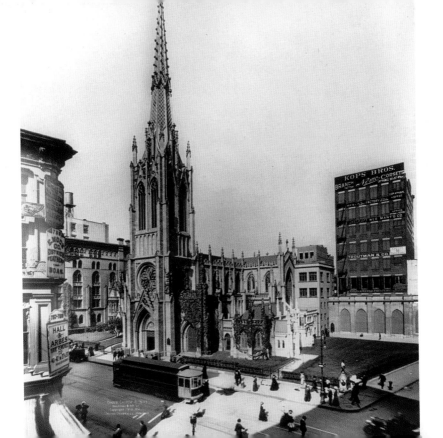

Grace Church, 1910

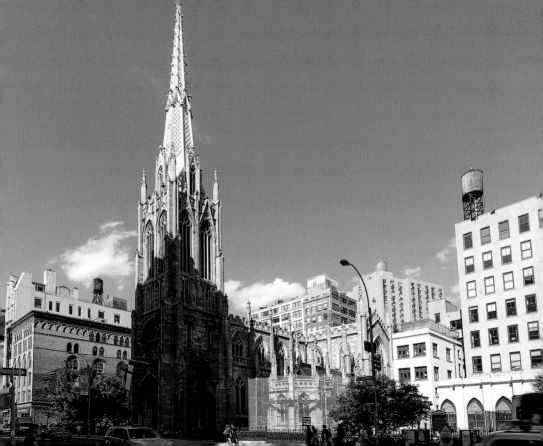

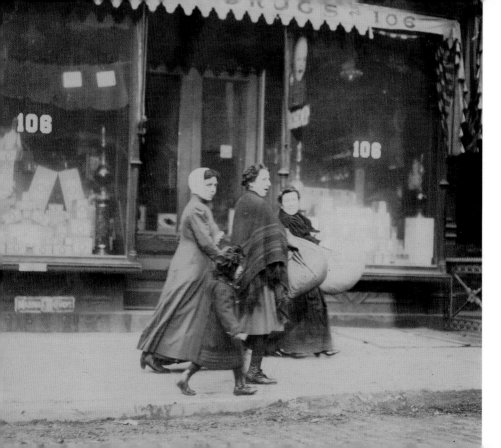

106 Macdougal Street, 1914

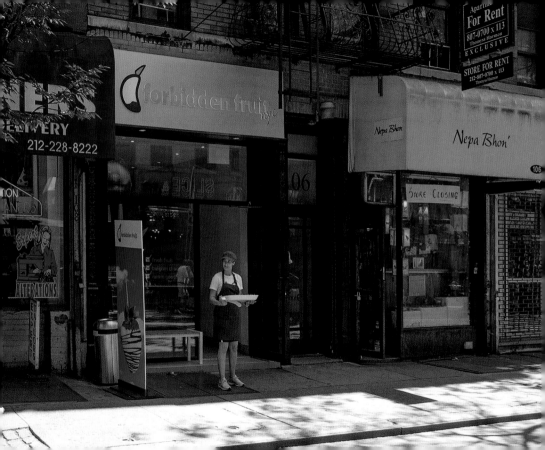

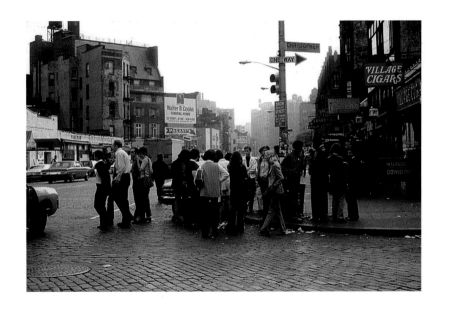

Seventh Avenue at Christopher Street, 1970

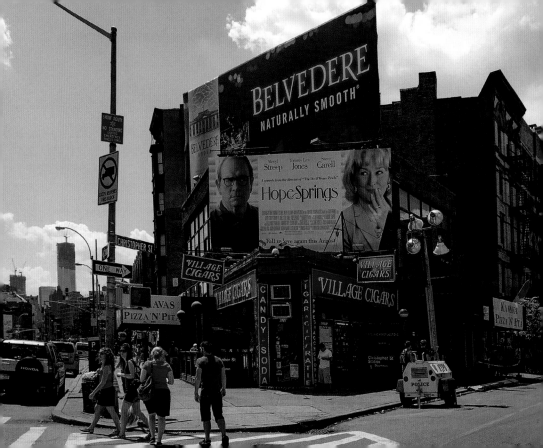

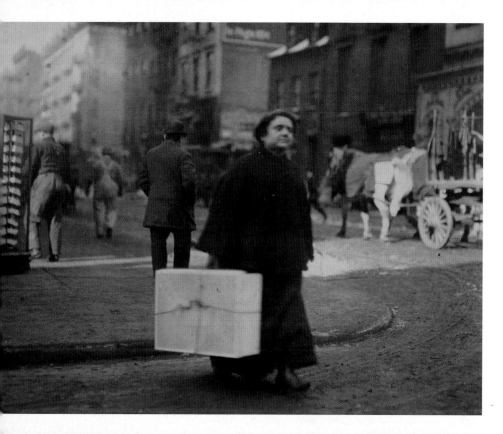

Bleeker Street from Thompson Street, 1914

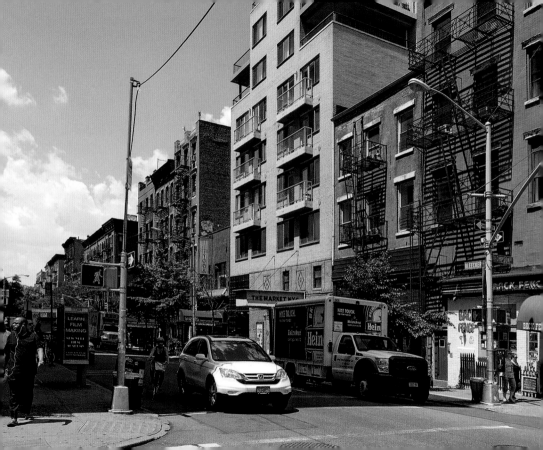

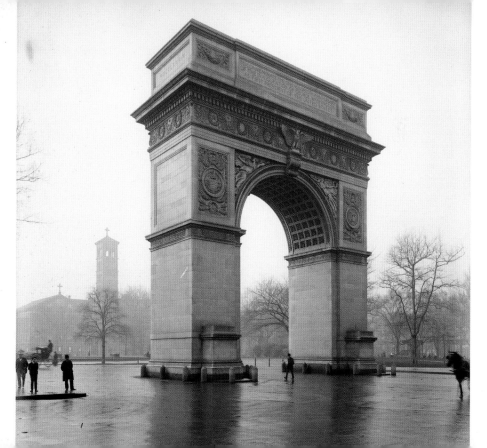

Washington Arch, Washington Square Park, 1900

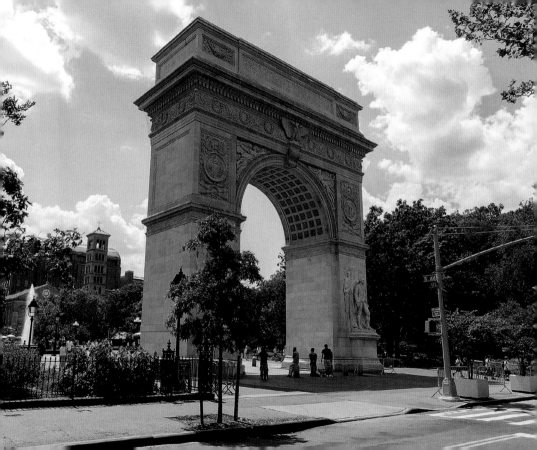

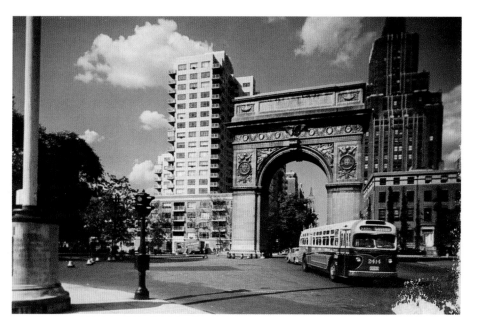

Washington Arch, Washington Square Park, c. 1955

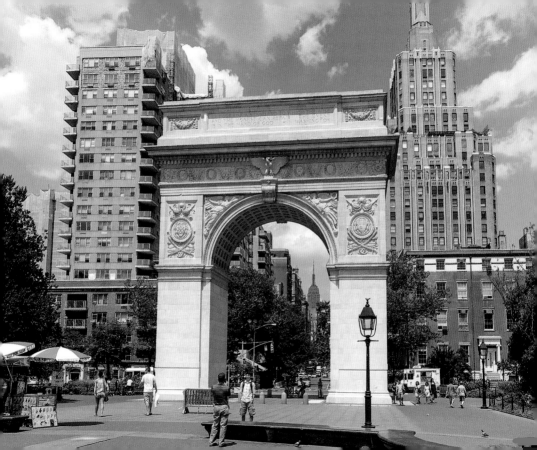

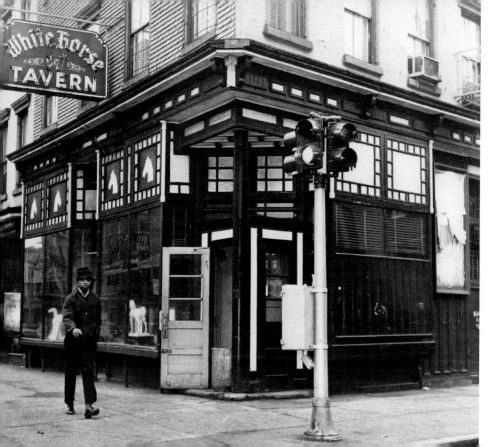

White Horse Tavern, Hudson and Eleventh Streets, 1961

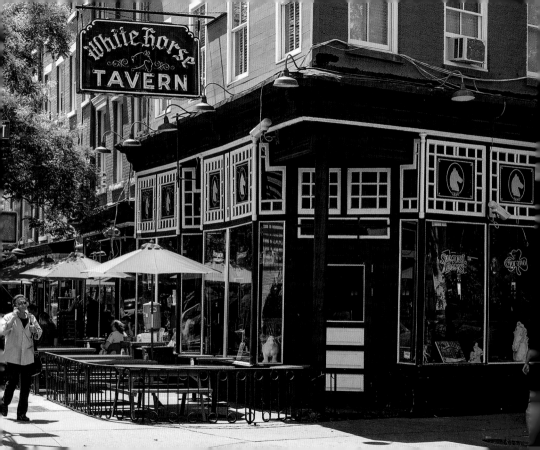

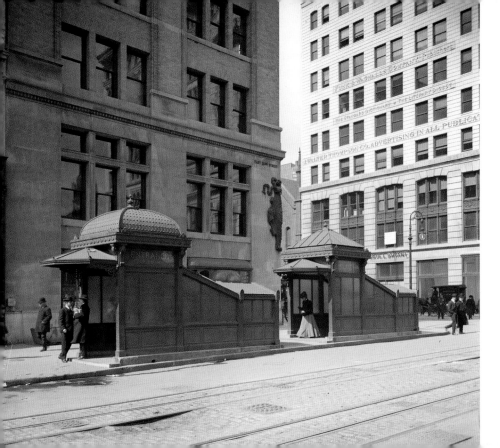

East 23rd at Park Avenue, c. 1905

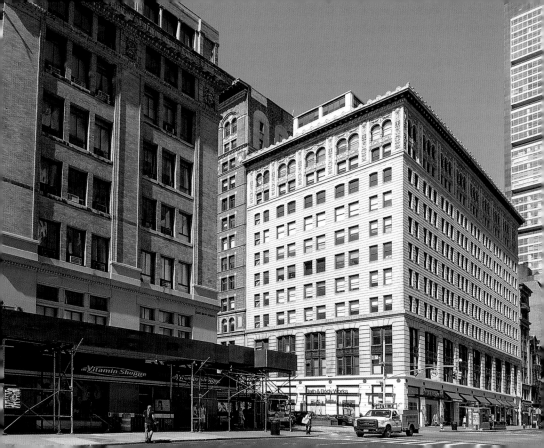

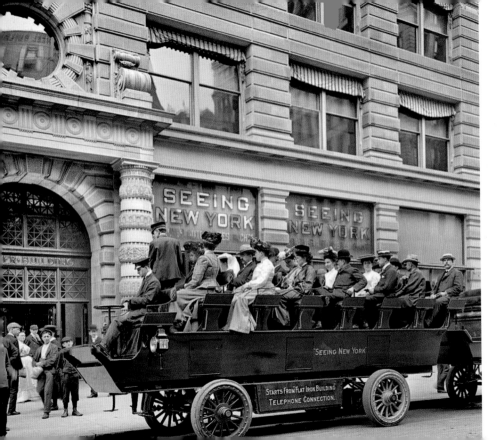

SEEING
NEW YORK

SEEING
NEW YORK

"SEEING NEW YORK"

STARTS FROM FLAT IRON BUILDING
TELEPHONE CONNECTION.

Sightseeing bus in front of Flatiron Building, c. 1910

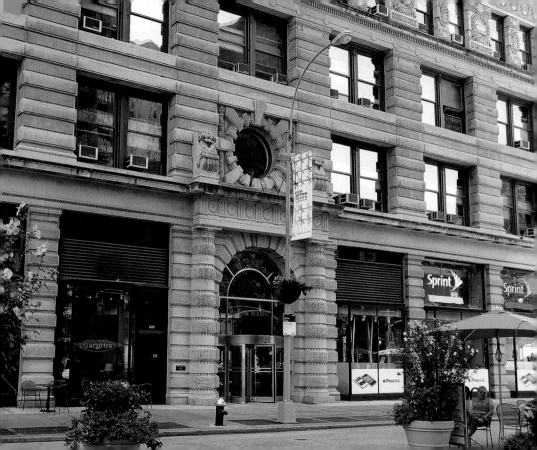

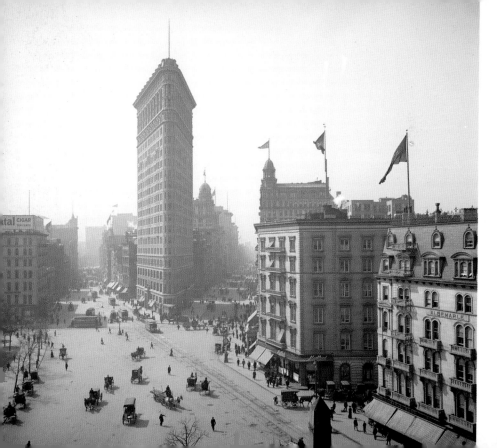

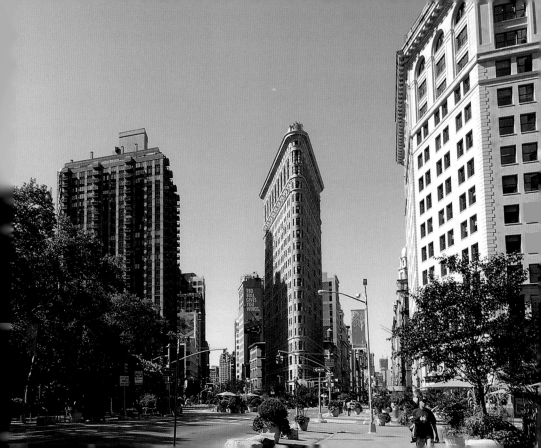

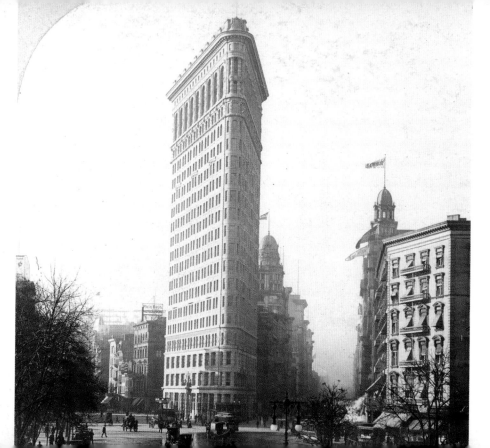

Flatiron Building, c. 1905

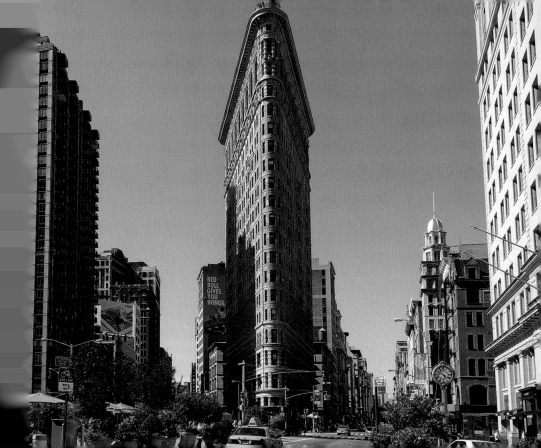

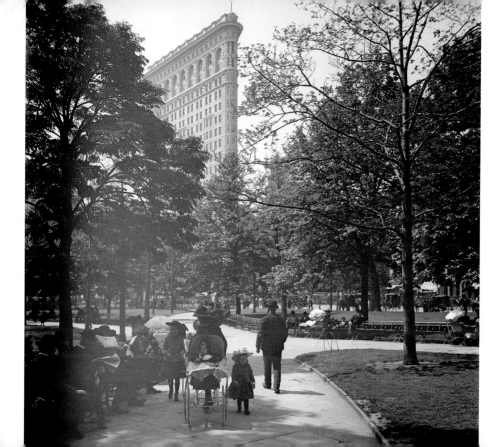

Flatiron Building from Madison Square Park, c. 1905

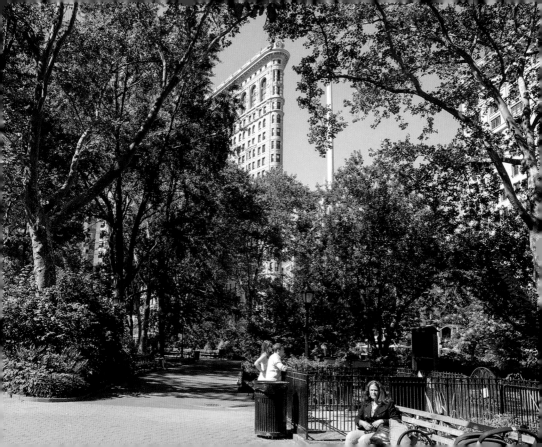

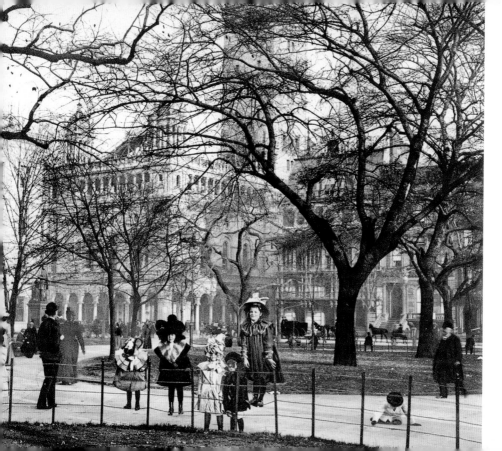

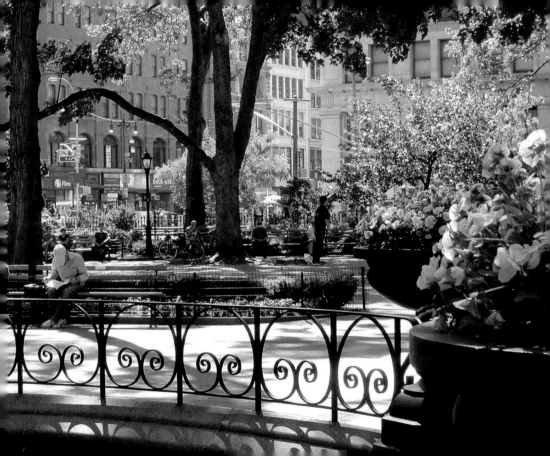

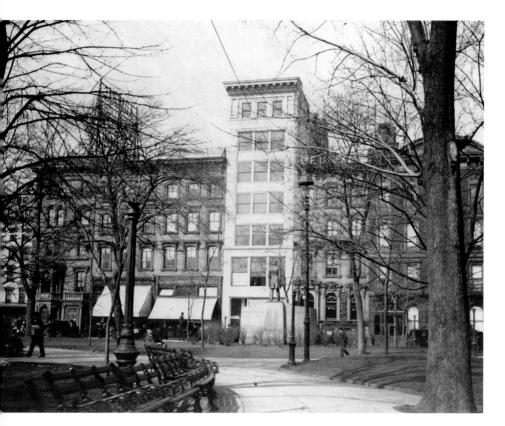

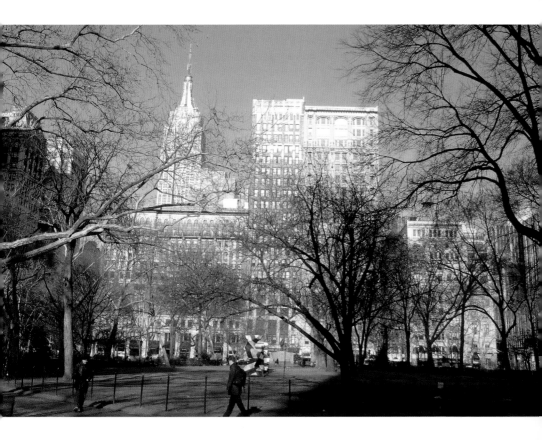

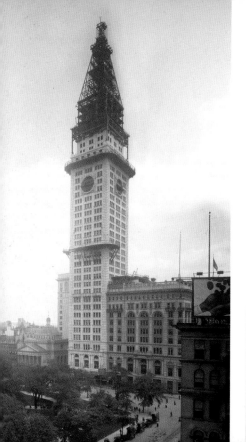
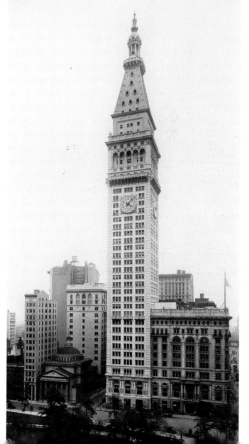

Metropolitan Life Building, under construction (1909) and completed (1911)

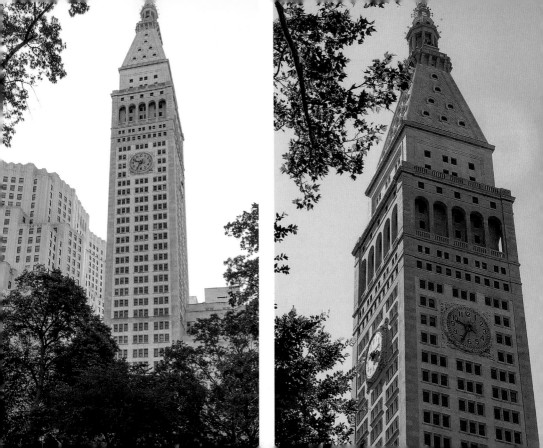

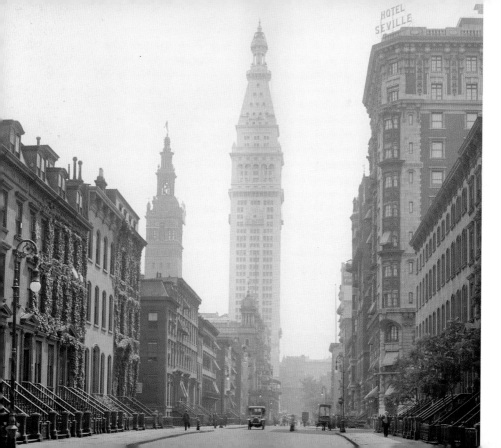

Metropolitan Life Building from Madison Avenue, c. 1910

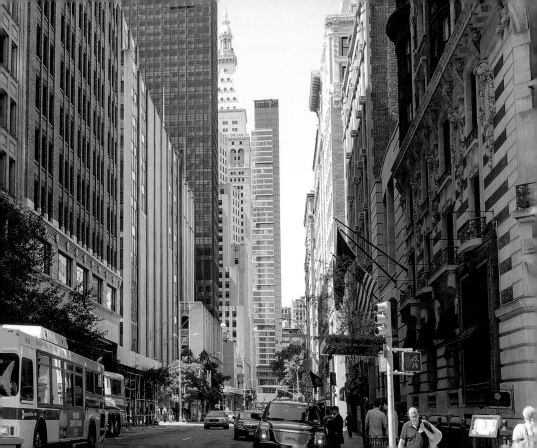

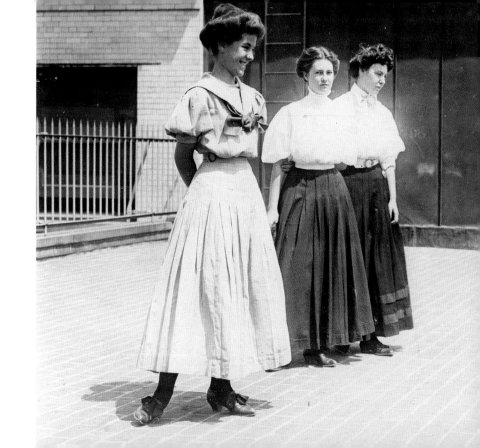

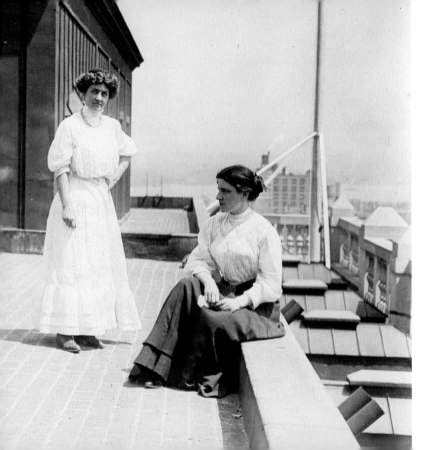

Clerks on the roof of the Metropolitan Life Building, c. 1915

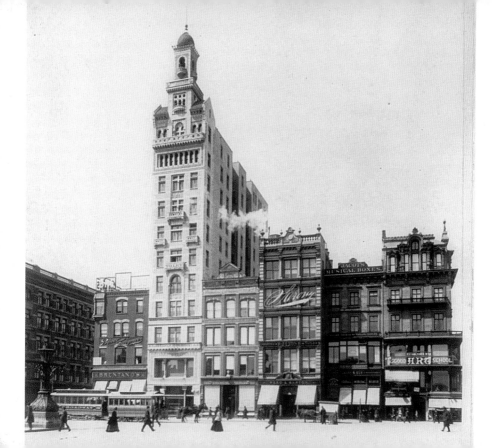

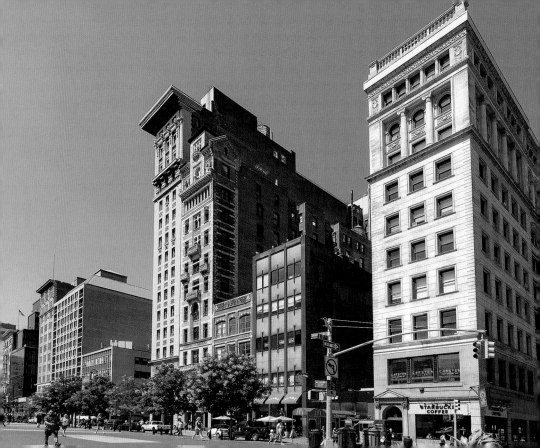

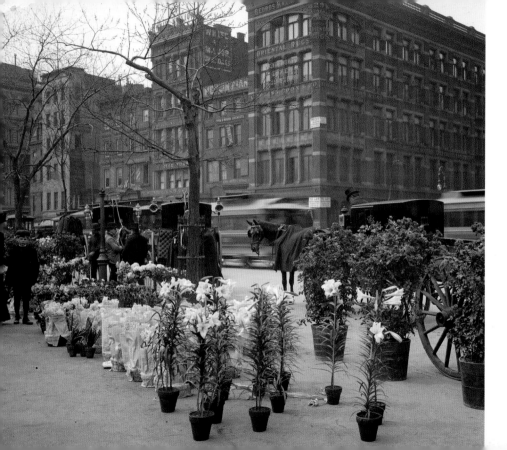

Union Square, c. 1905

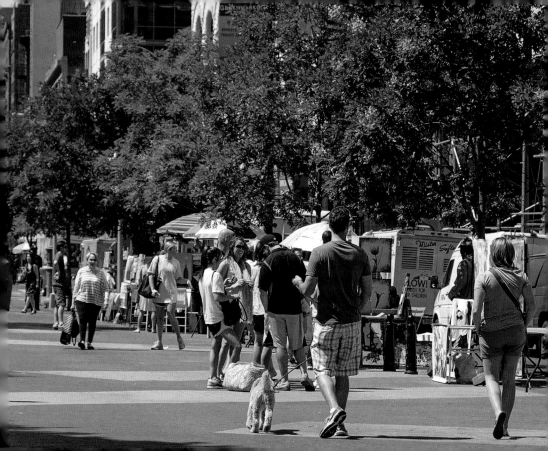

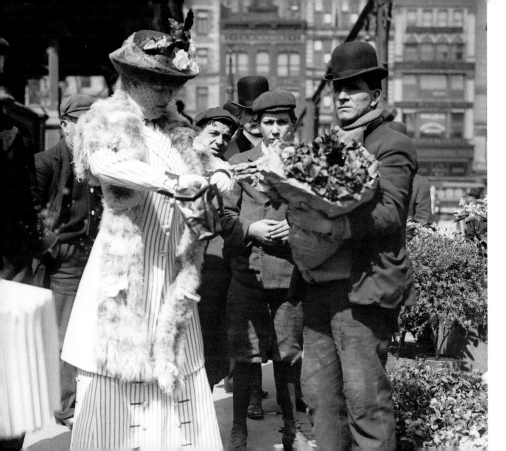

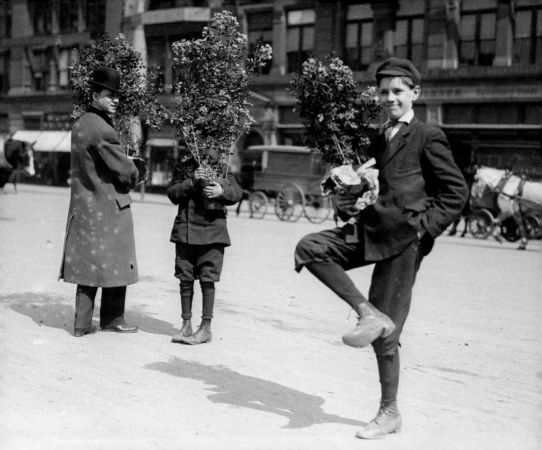

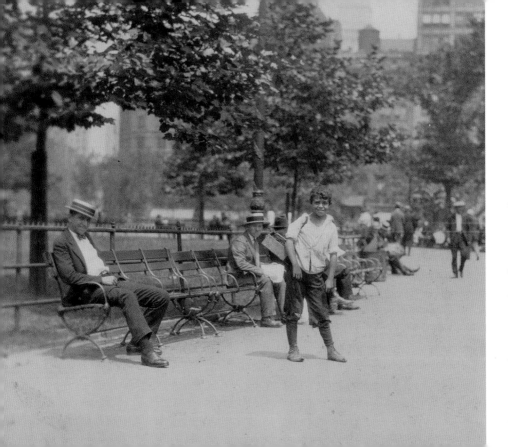

A shoe-shine boy in Union Square, 1913

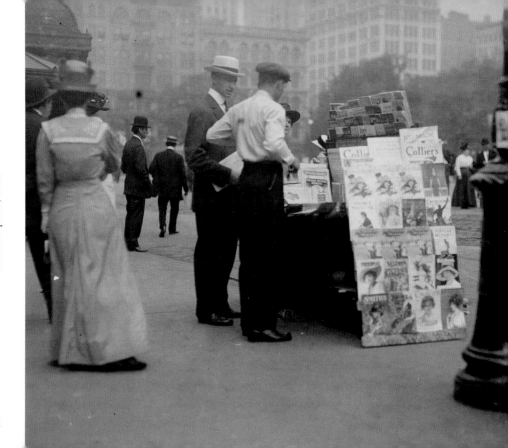

Union Square, 1913

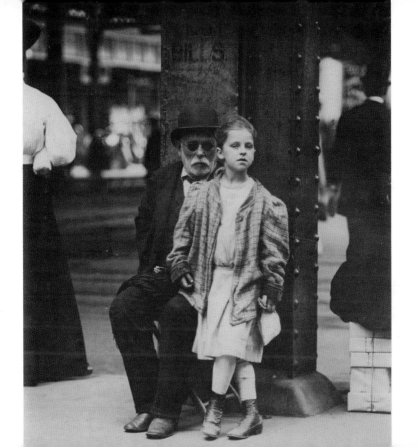

Sixth Avenue and 14th Street, 1910

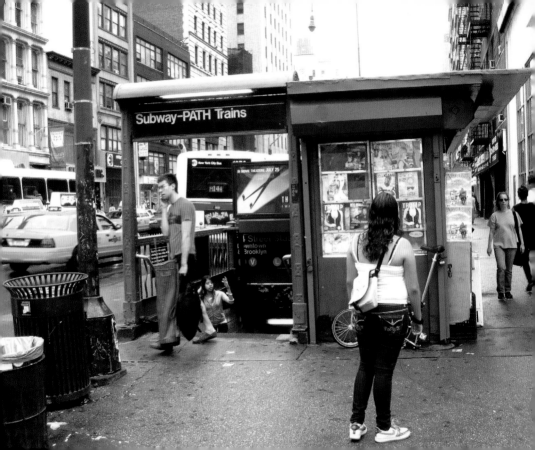

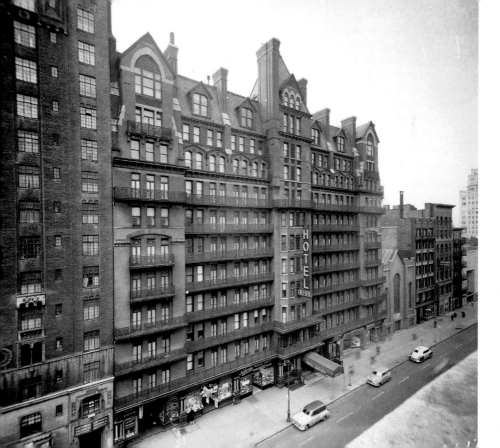

Hotel Chelsea, West 23rd Street, c. 1955

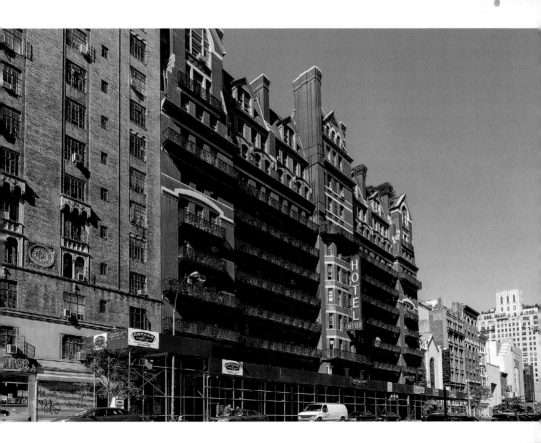

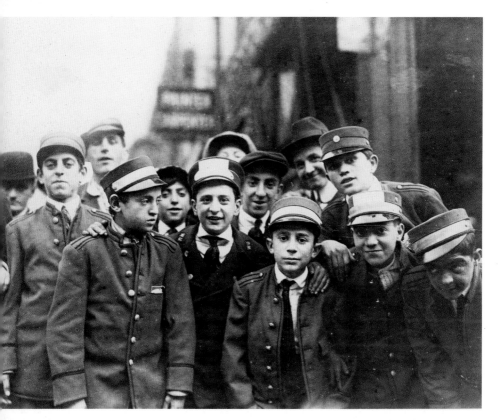

Messenger boys at Sixth Avenue and 32nd Street, 1916

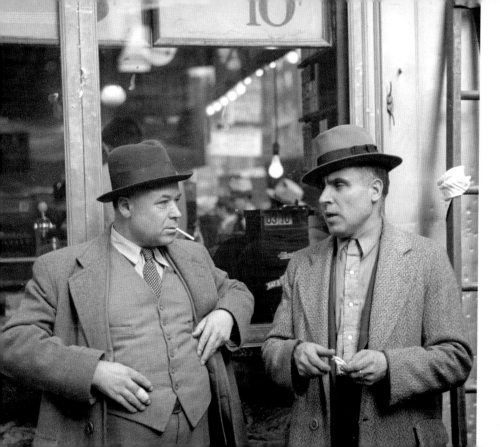

INTRODUCED AT "THE NEW YORK TIMES"
INTRODUCED AT "GQ"
INTRODUCED AT "ESQUIRE"
INTRODUCED AT "PIX 11 MORNING NEWS"

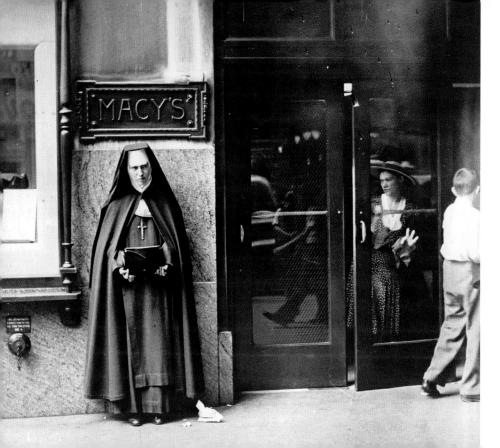

Macy's, 1939 (left) and c. 1910 (right)

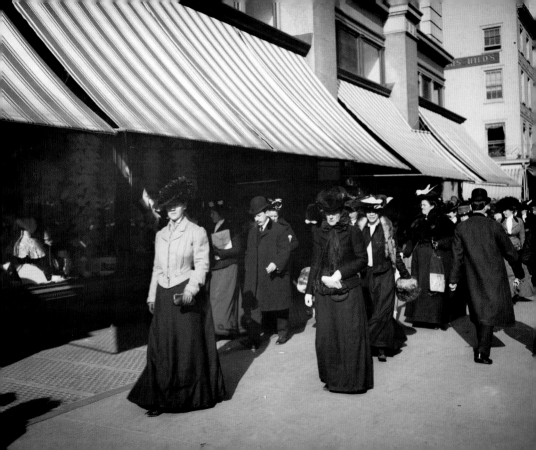

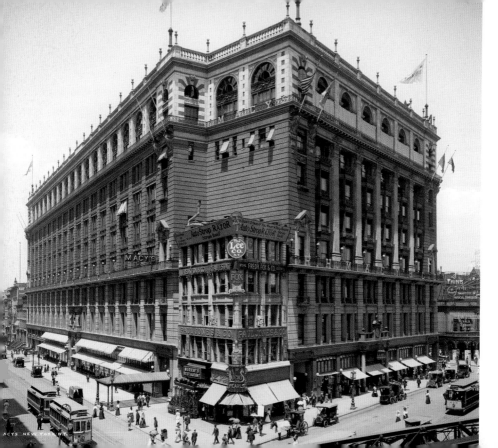

Macy's, 1908

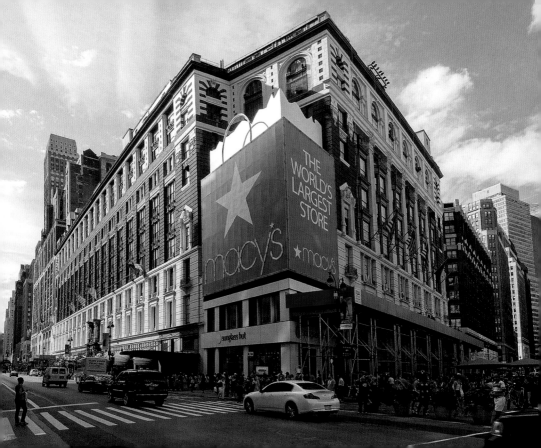

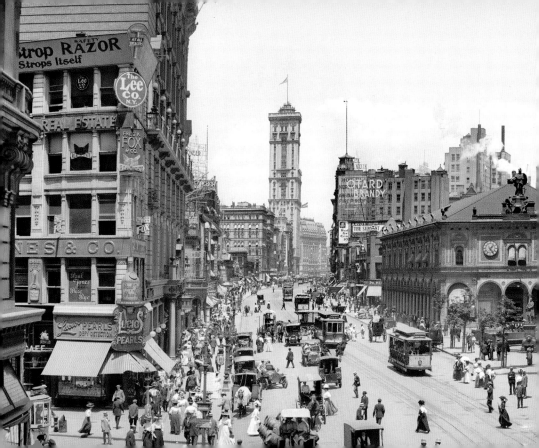

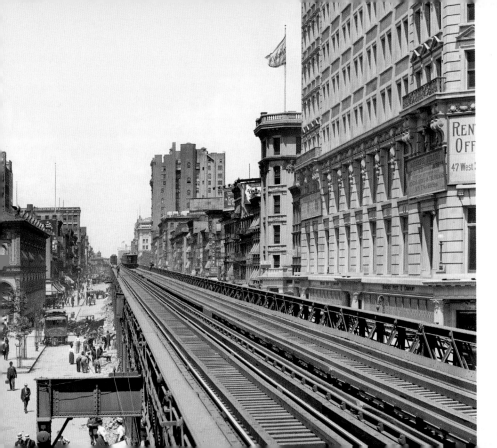

Herald Square, c. 1910

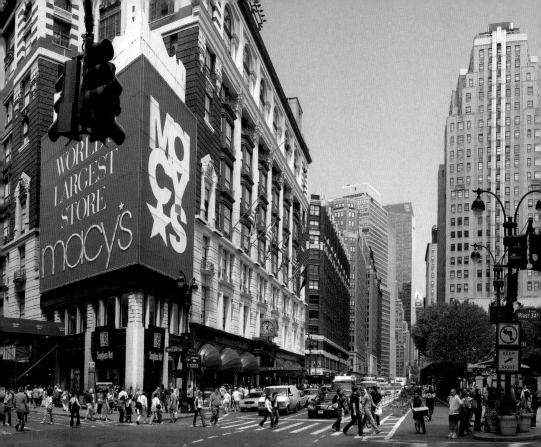

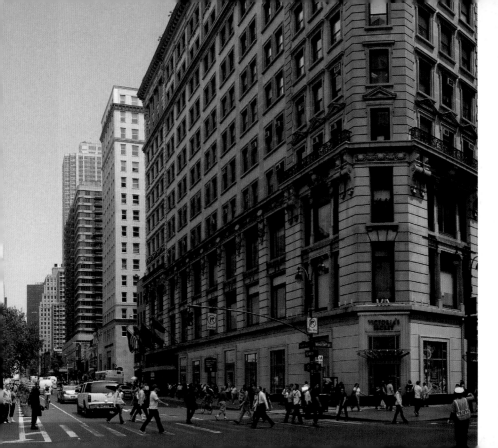

Herald Square

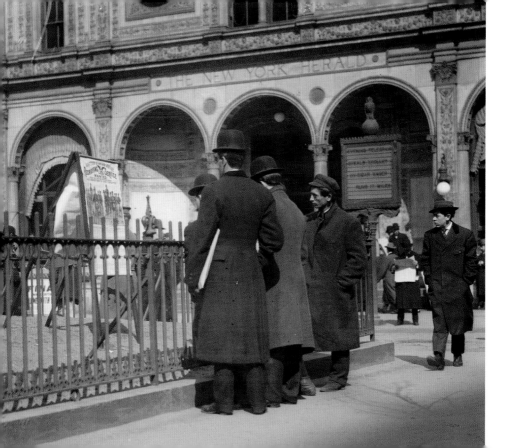

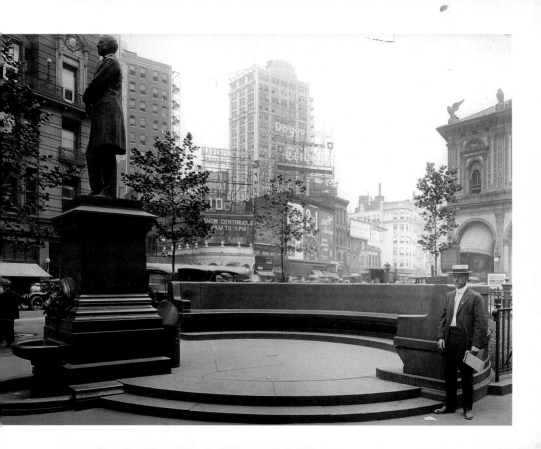

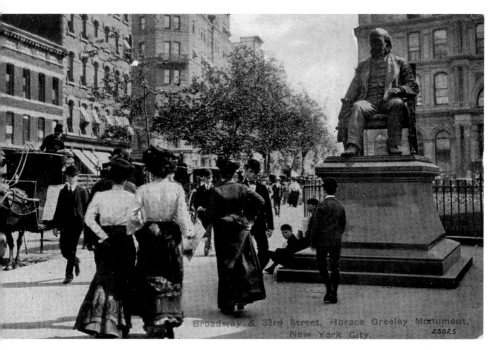

Broadway & 33rd Street, Horace Greeley Monument, New York City. 25925

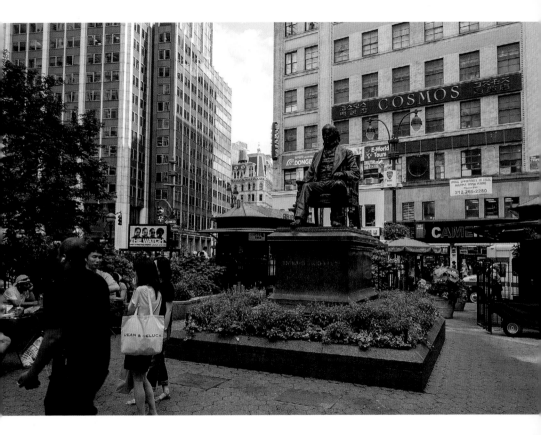

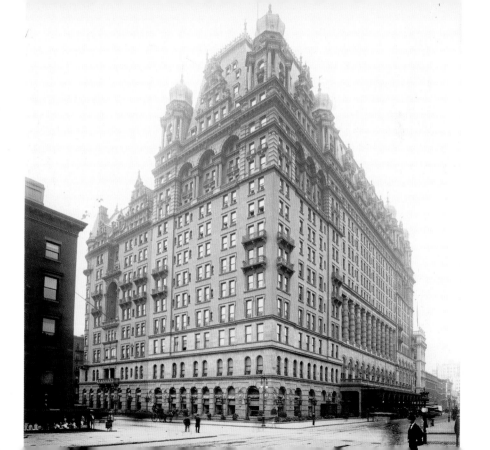

The Waldorf-Astoria, c. 1900

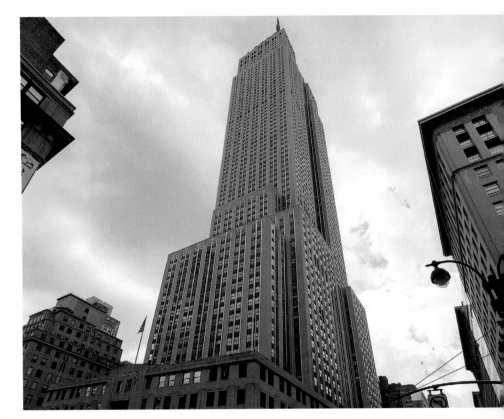

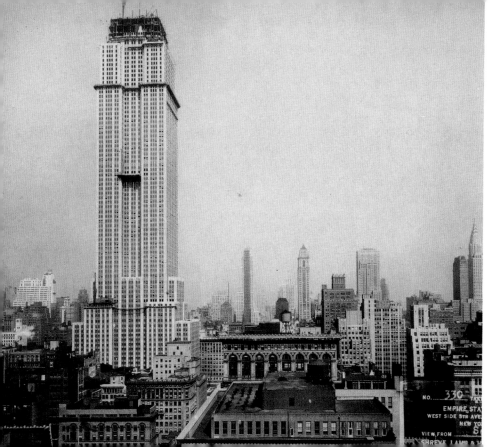

Empire State Building, 1930

154

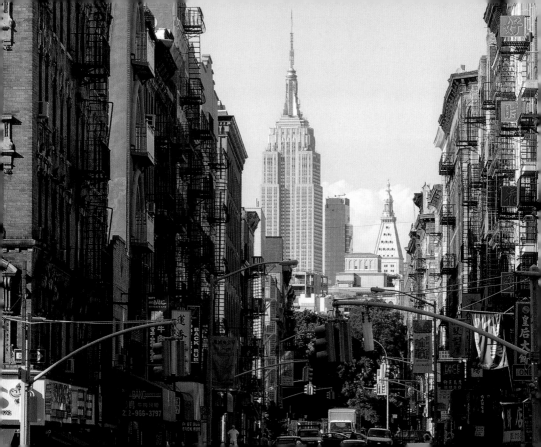

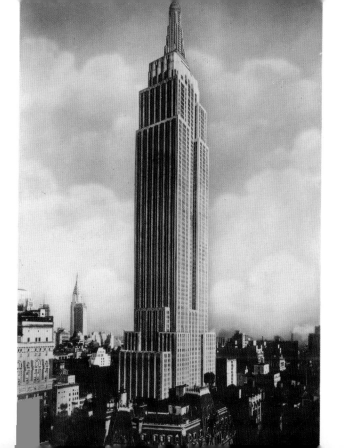

Empire State Building, c. 1935

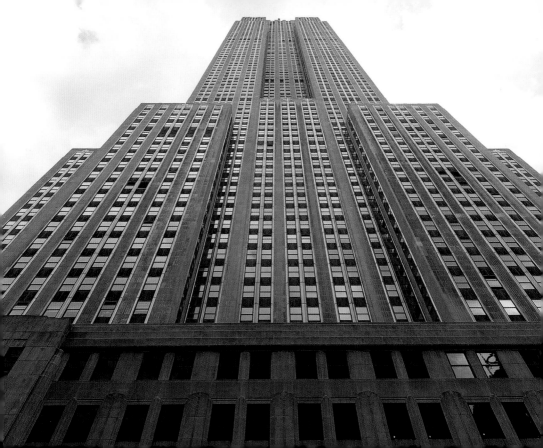

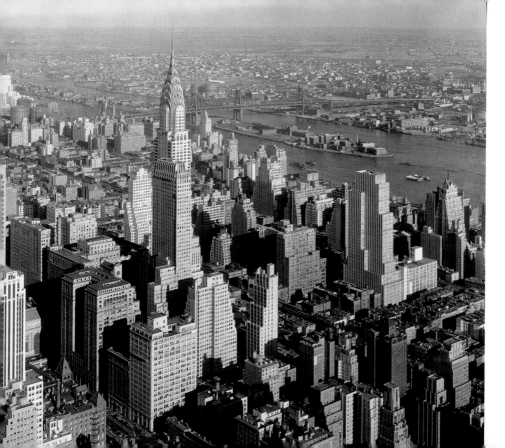

View from the Empire State Building, 1932

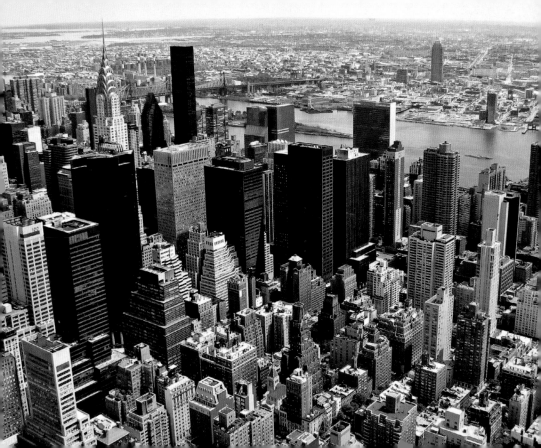

View from the Empire State Building, 1933

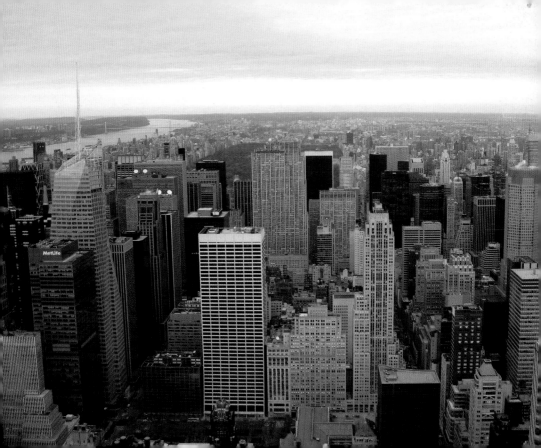

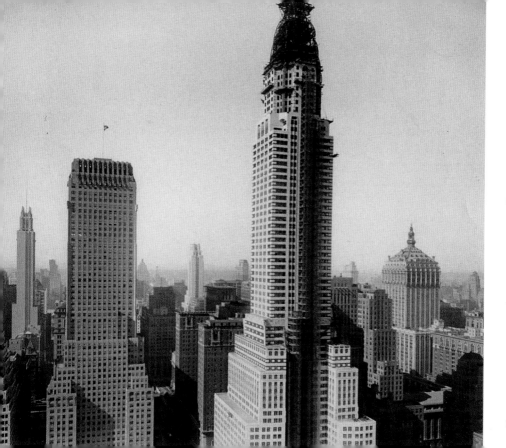

Chrysler Building under construction, 1929

Chrysler Building from Second Avenue, c. 1930

163

Chrysler Building, 1930

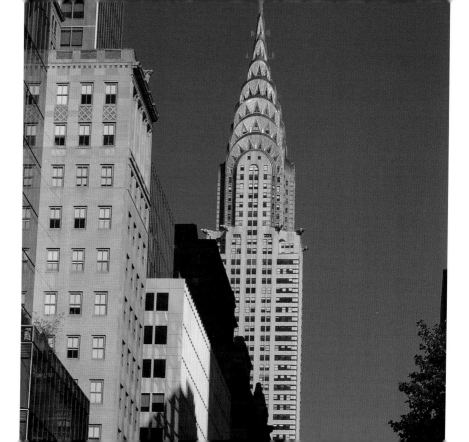

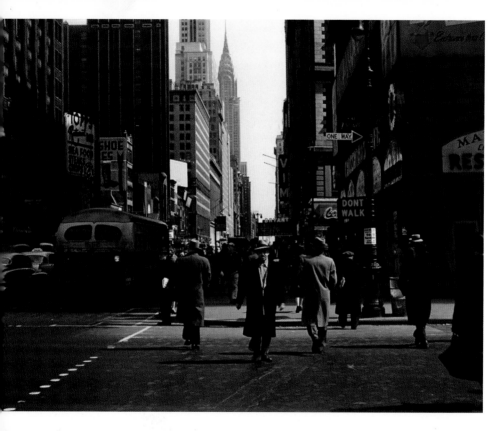

Chrysler Building from 42nd Street, c. 1945

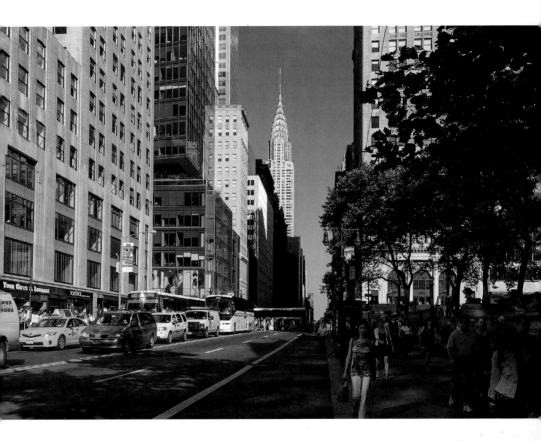

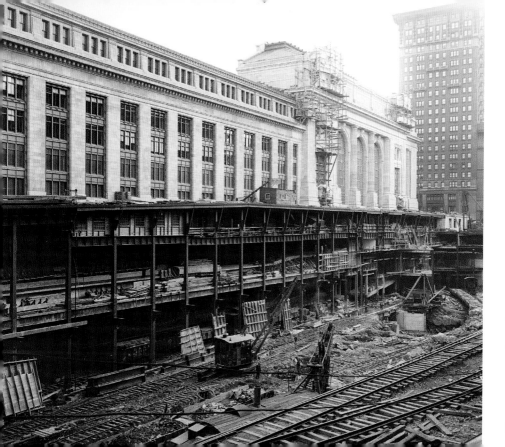

Grand Central Station under construction, 1912

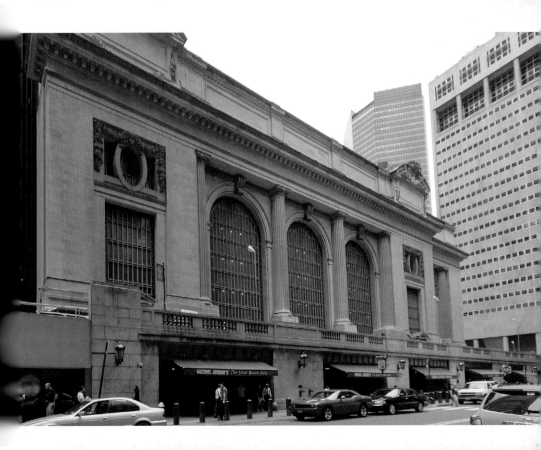

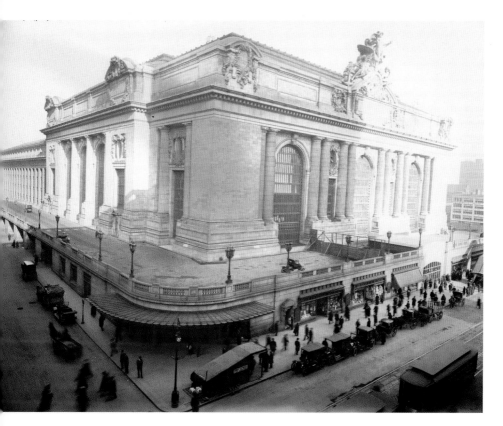

Grand Central Station, c. 1915

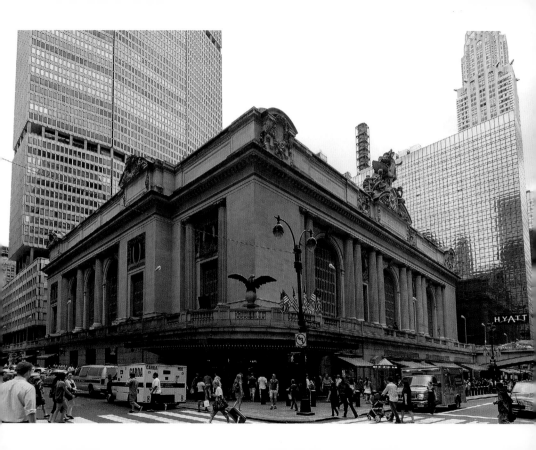

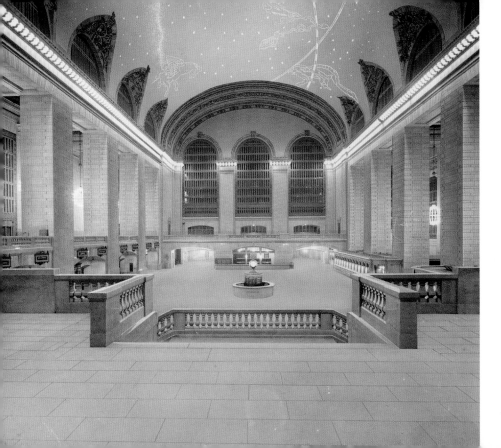

Grand Central Station, 1913

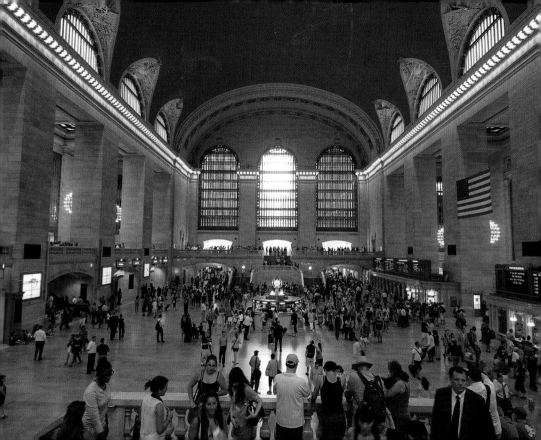

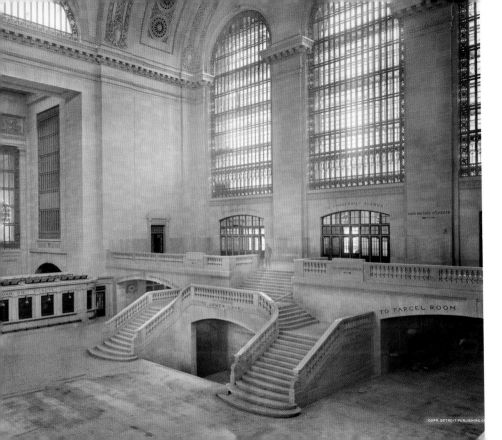

Grand Central Station, 1913

TO LOWER LEVEL

TO PARCEL ROOM

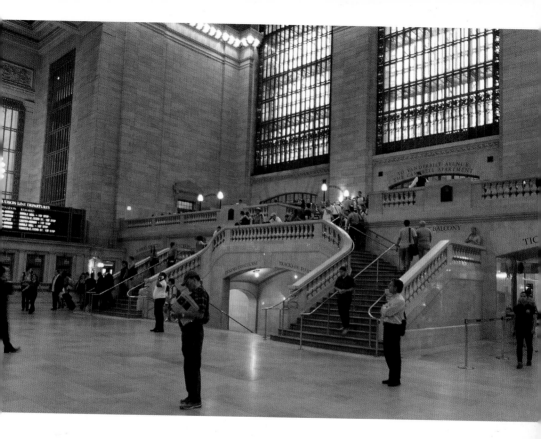

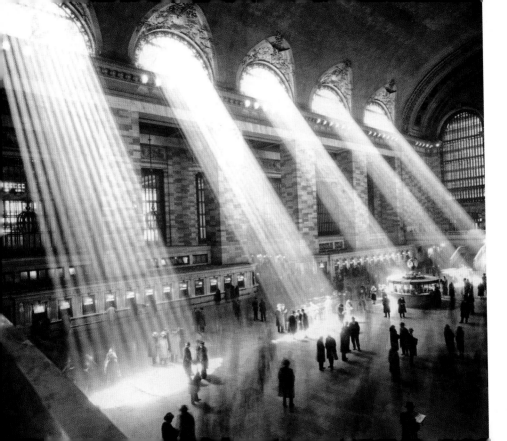

Grand Central Station, 1929

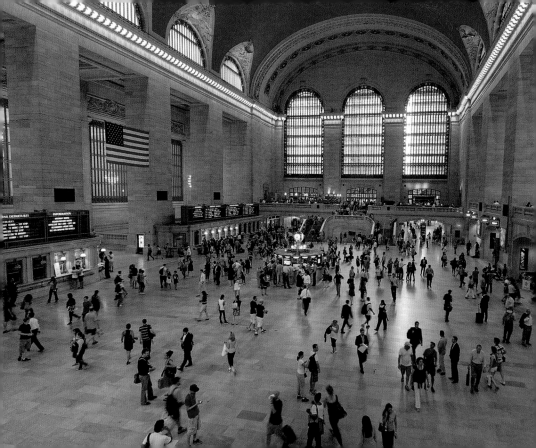

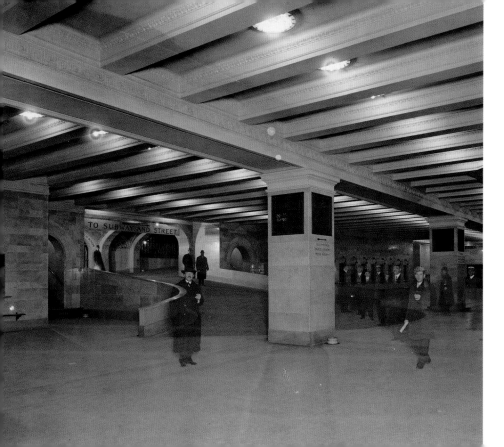

Grand Central Station, 1913

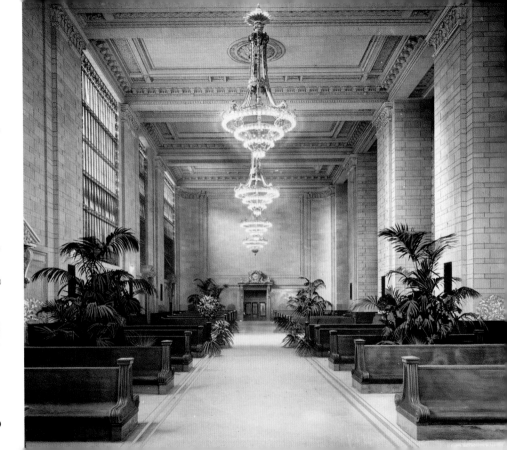

Main waiting room, Grand Central Station, 1913

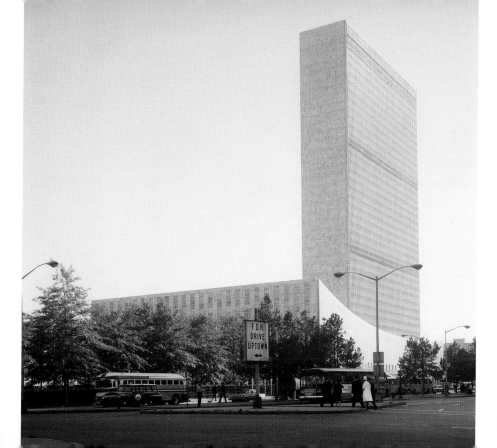

United Nations Headquarters, 1966

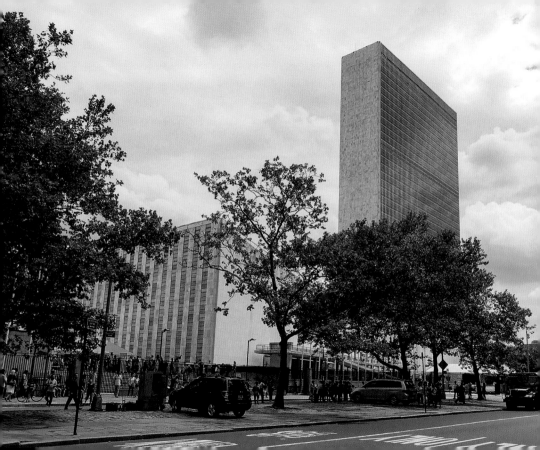

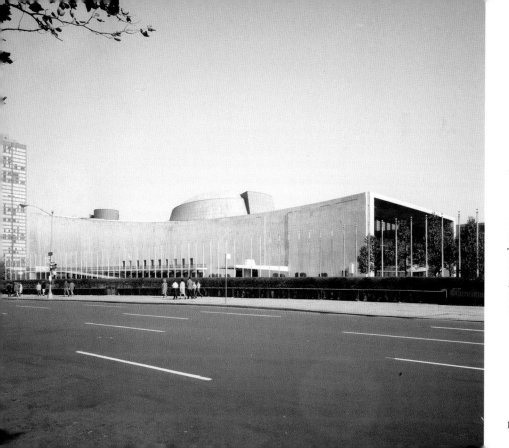

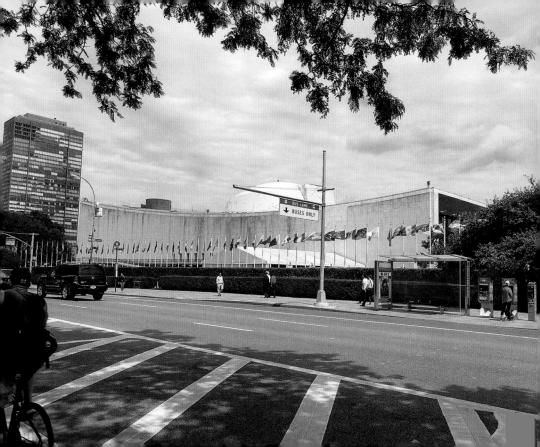

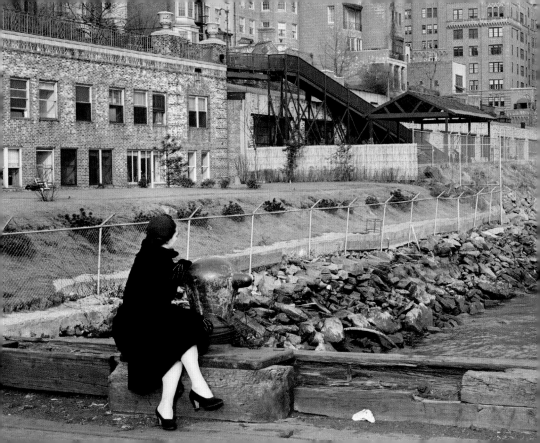

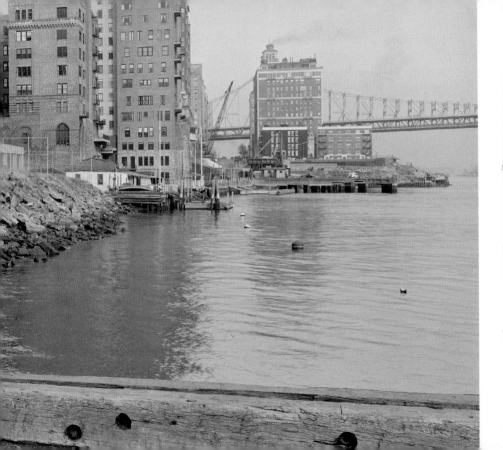

East River looking north toward Queensboro Bridge, 1938

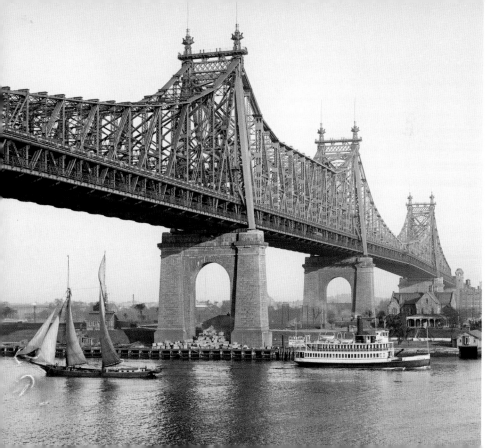

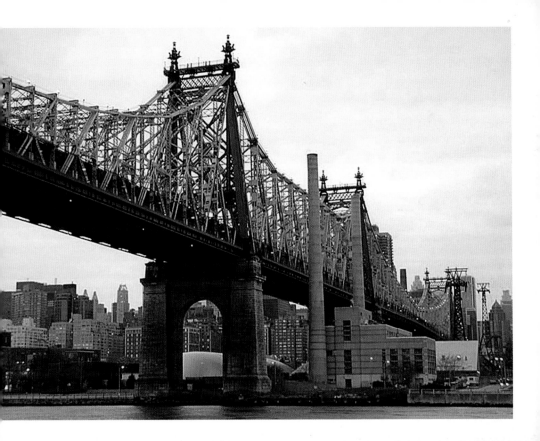

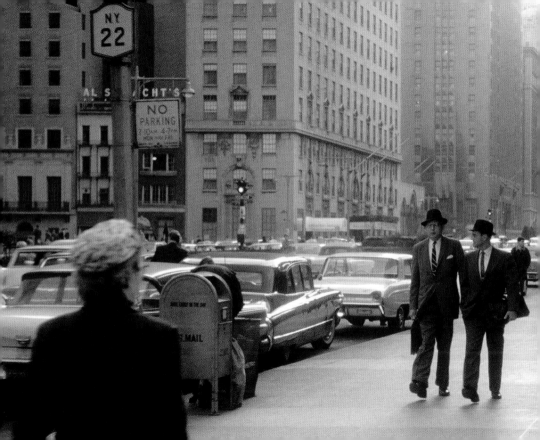

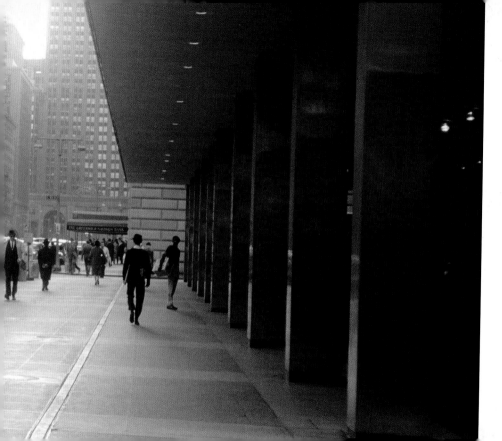

Park Avenue at 54th Street, 1961

189

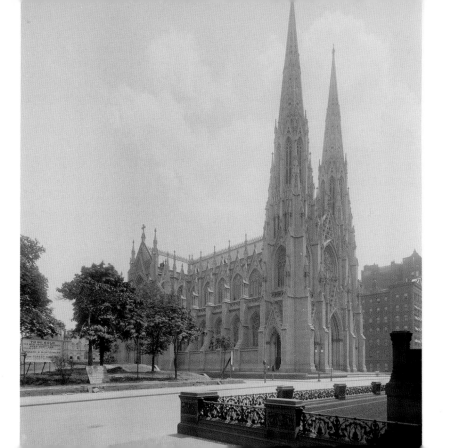

St. Patrick's Cathedral, c. 1905

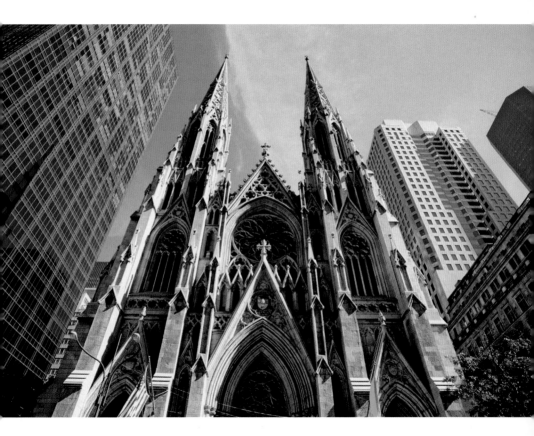

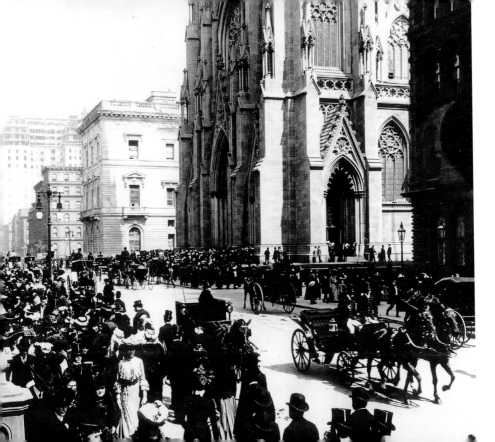

St. Patrick's Cathedral, c. 1905

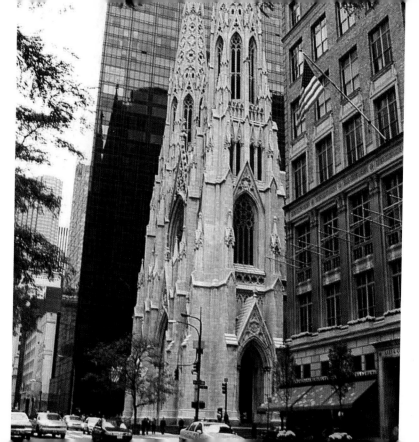

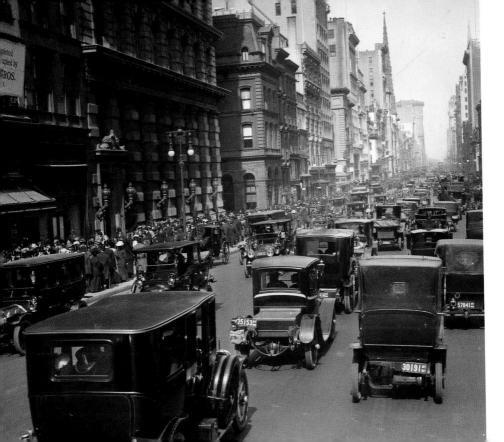

194

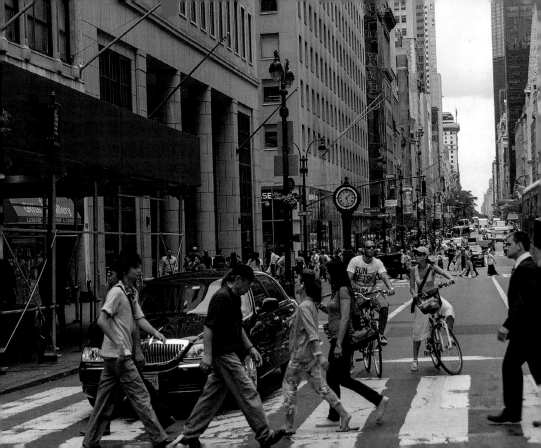

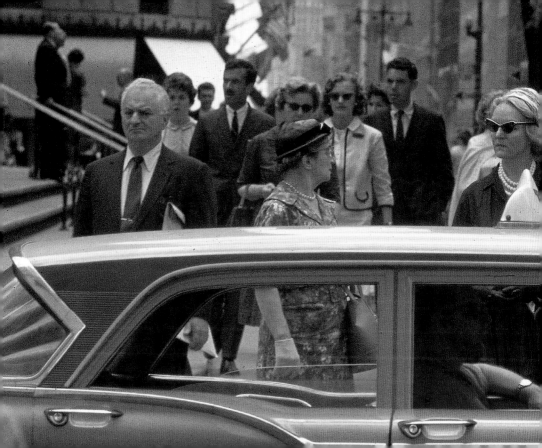

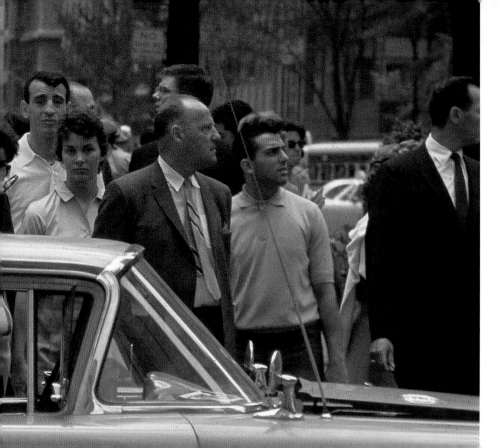

Fifth Avenue at East 50th Street, c. 1960

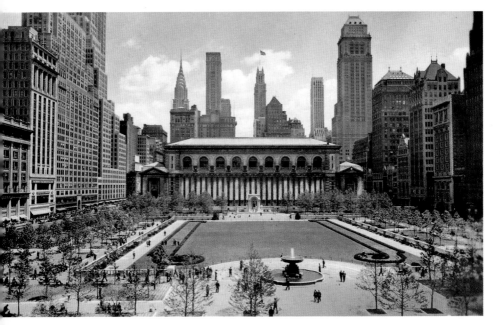

Bryant Park, c. 1937

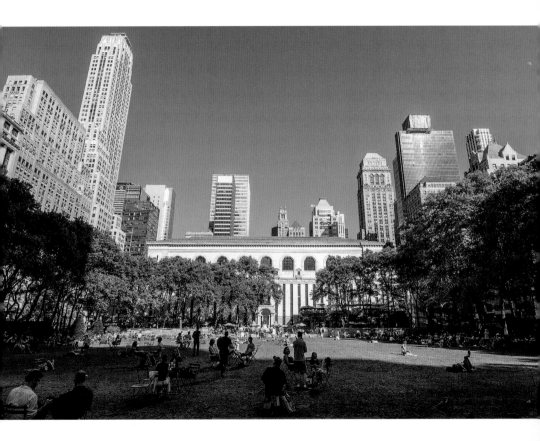

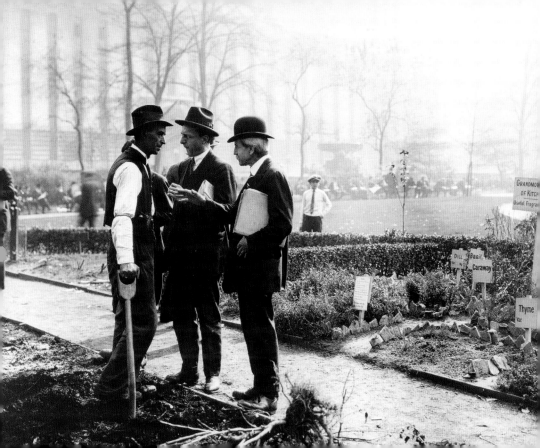

City experiment in gardening, Bryant Park, 1918

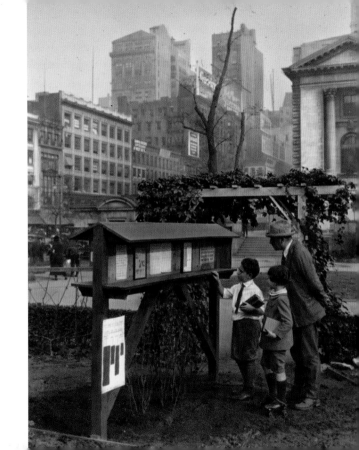

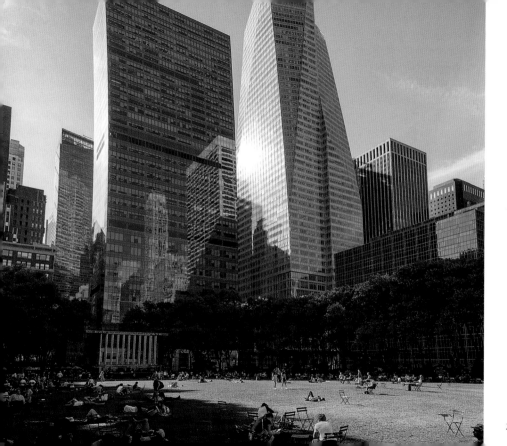

Bryant Park

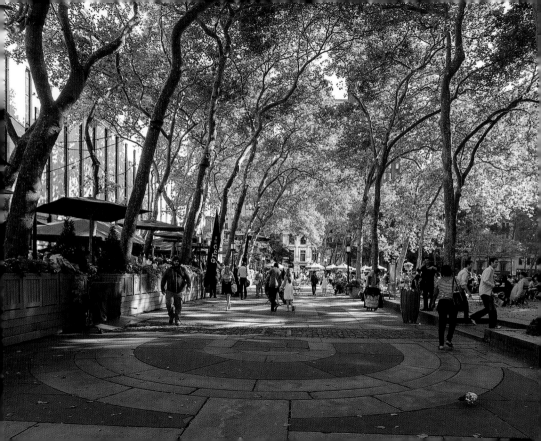

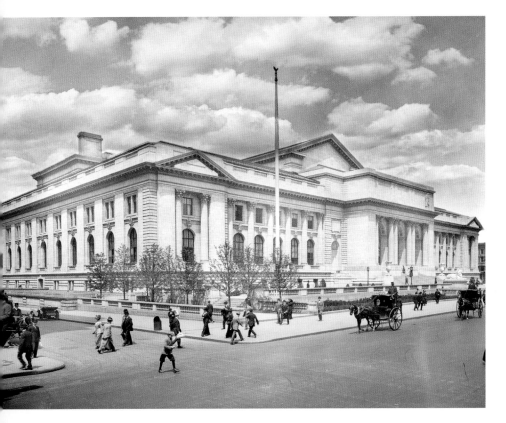

New York Public Library, c. 1910

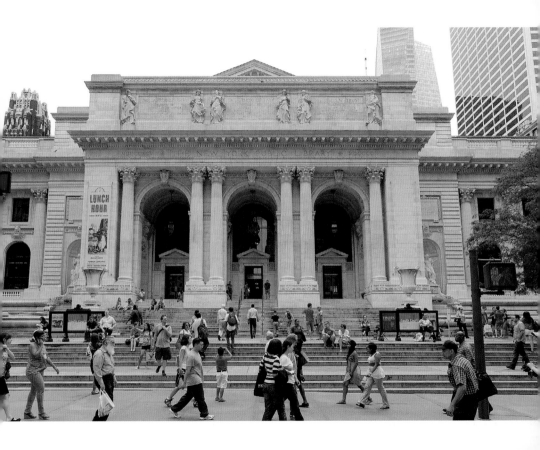

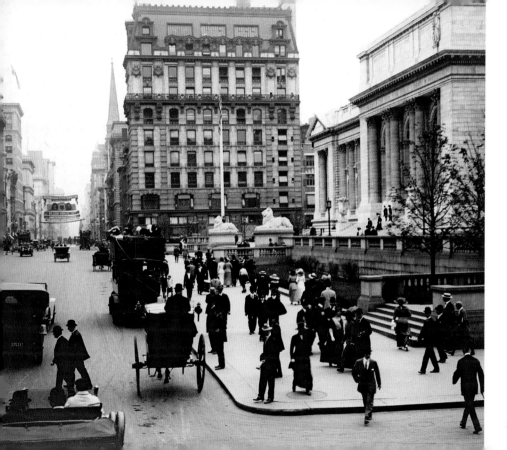

New York Public Library, c. 1910

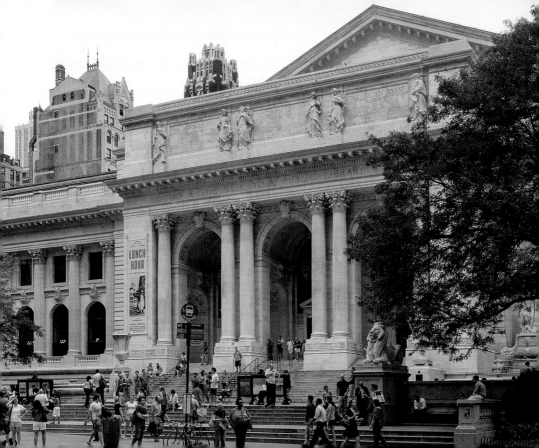

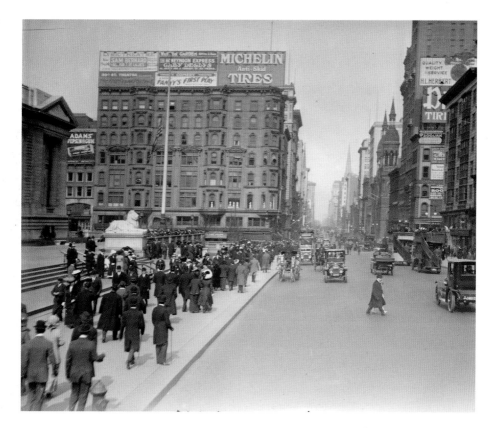

New York Public Library and Fifth Avenue, 1913

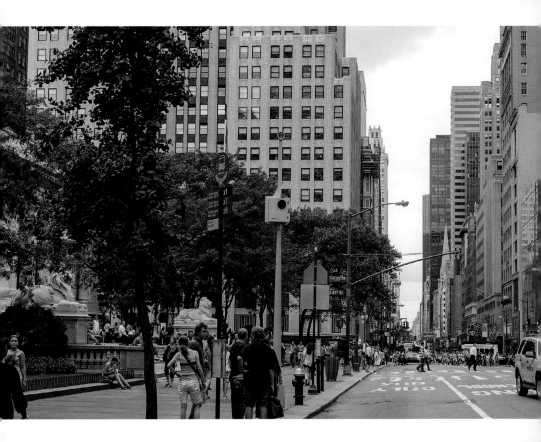

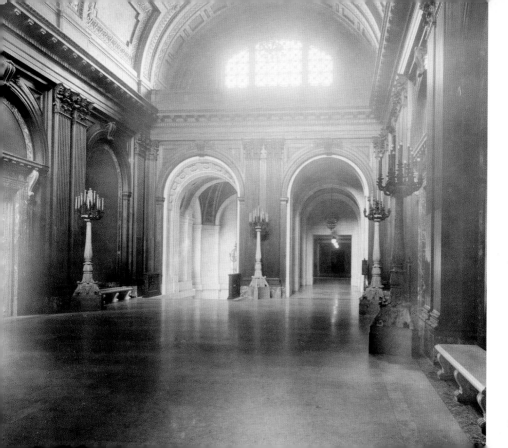

New York Public Library, c. 1910

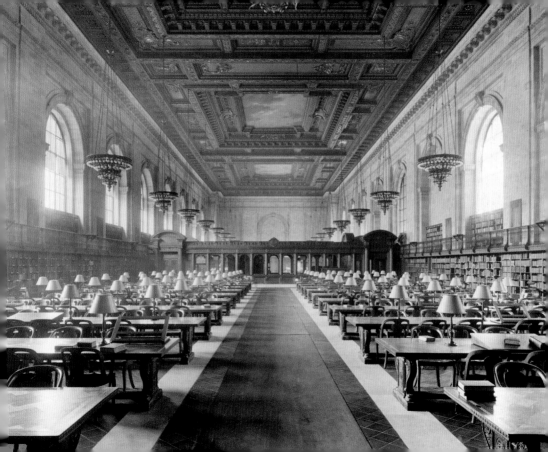

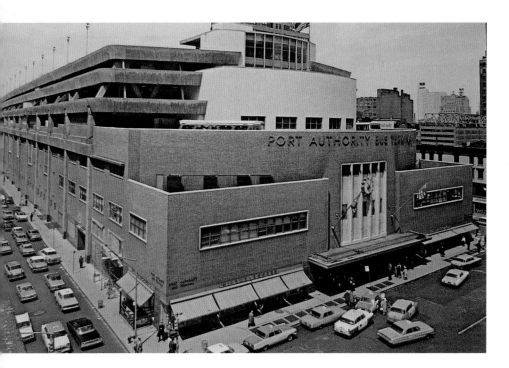

Port Authority Bus Terminal, c. 1960

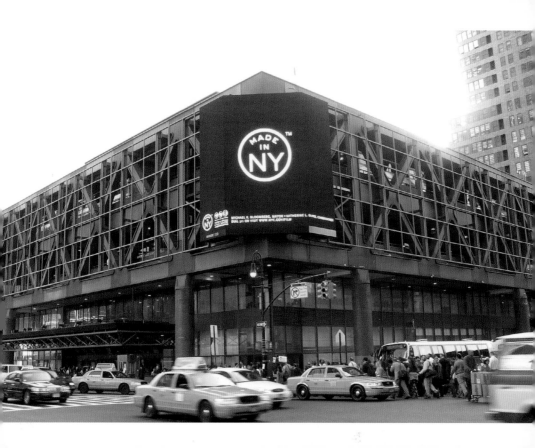

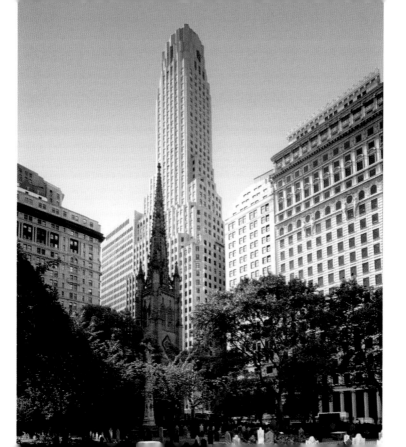

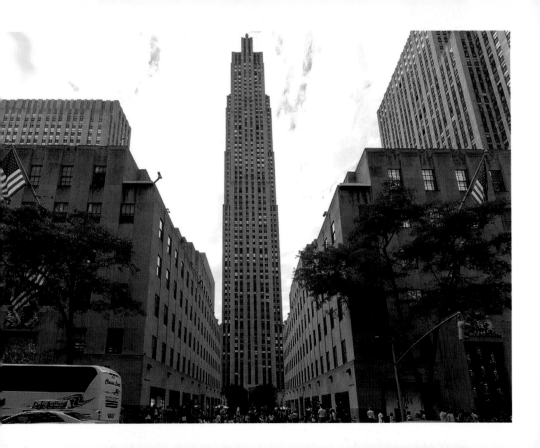

Rockefeller Center, 1943

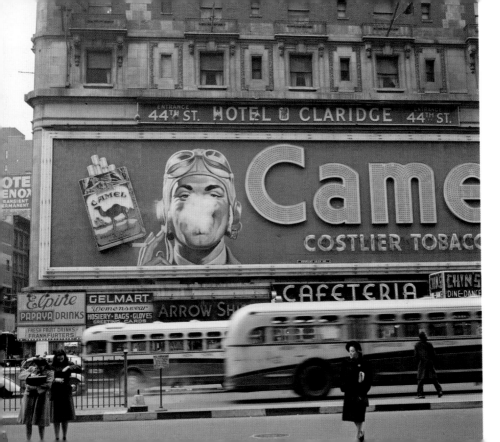

Broadway at 44th Street, 1943

218

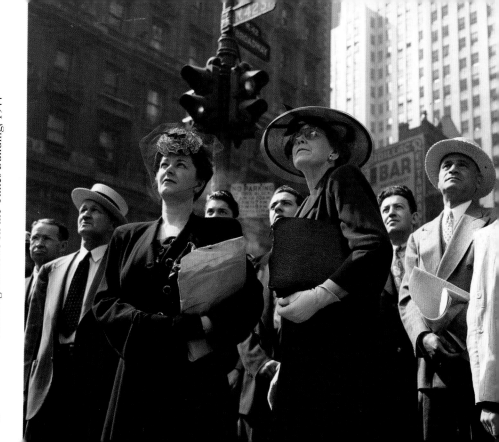

Watching the news on the Times Building, 1944

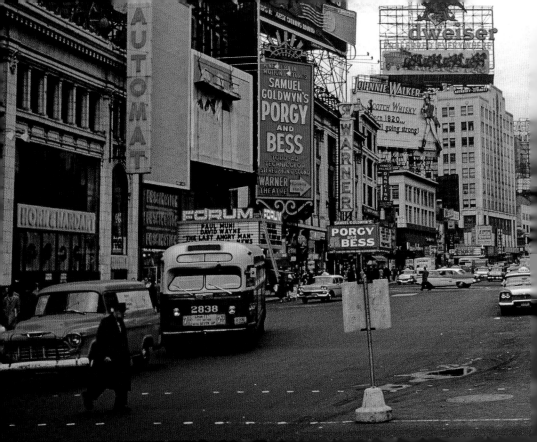

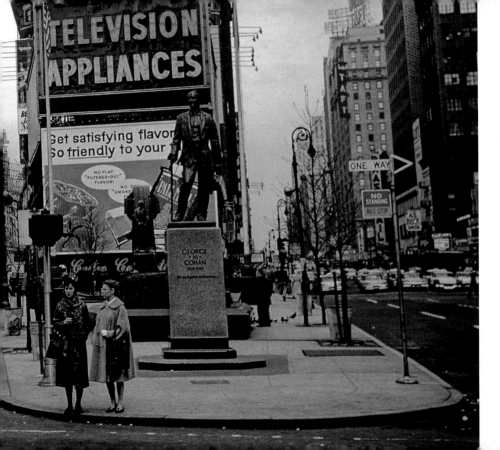

221

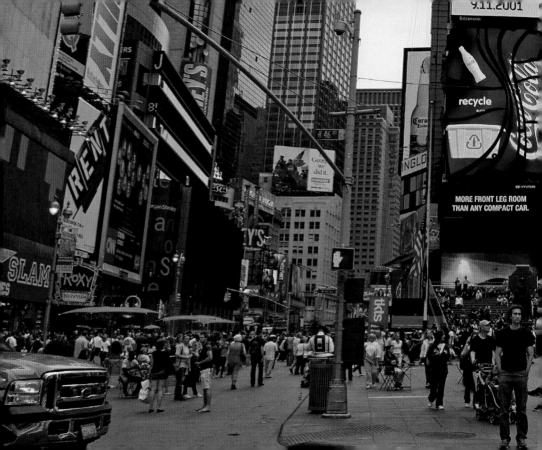

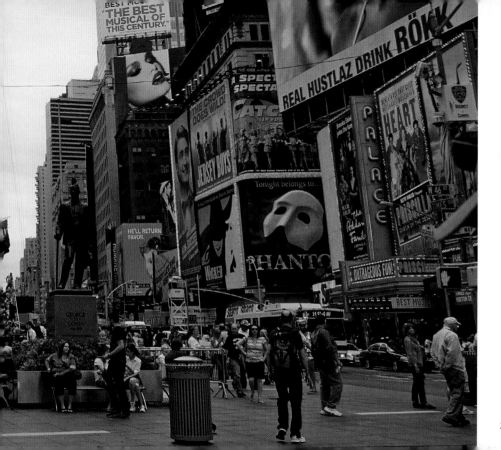

Broadway and Seventh Avenue at 47th Street

223

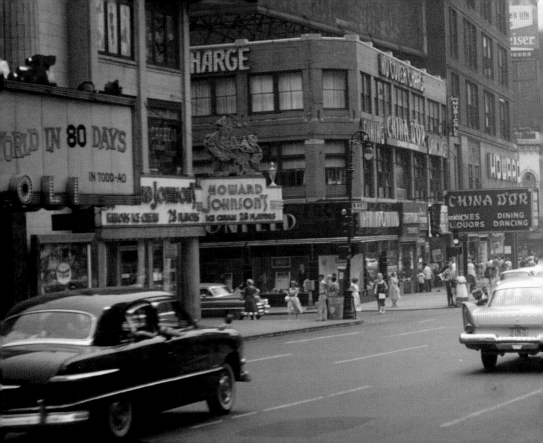

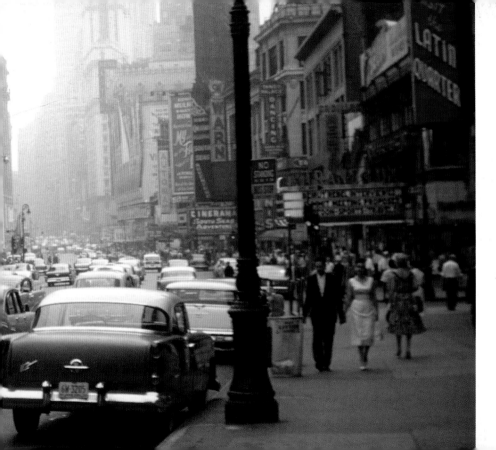

Broadway at 49th Street, 1958

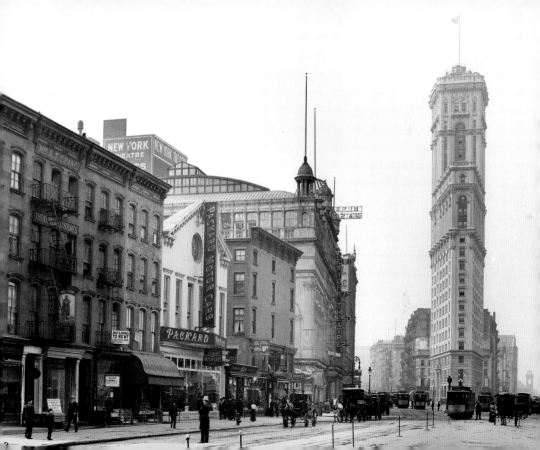

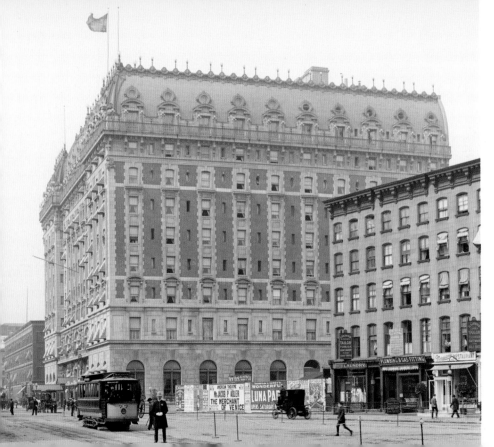

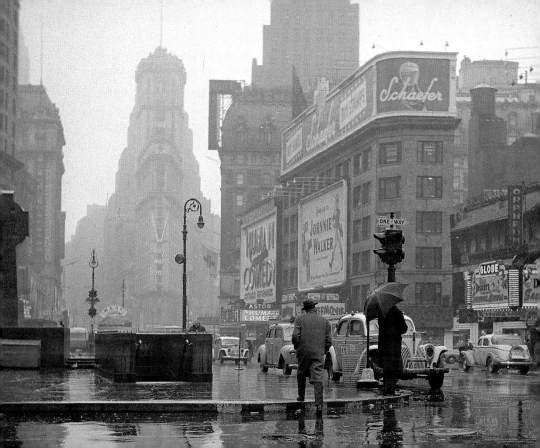

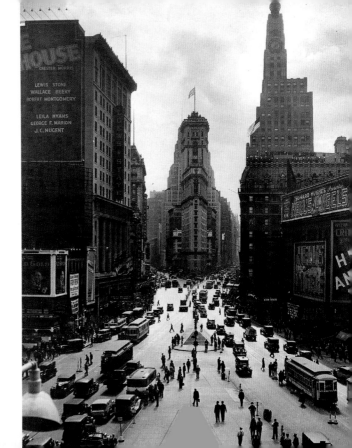

Times Square, 1943 (left) and 1930 (right)

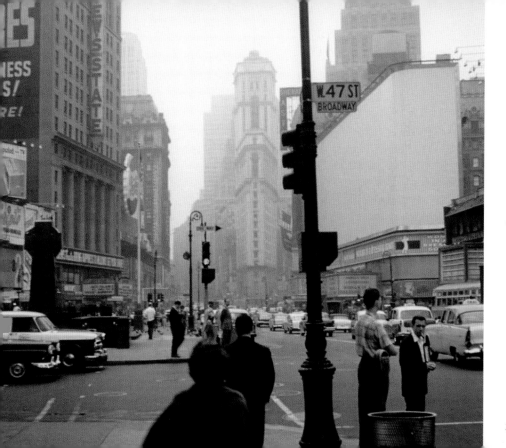

Times Square, 1957

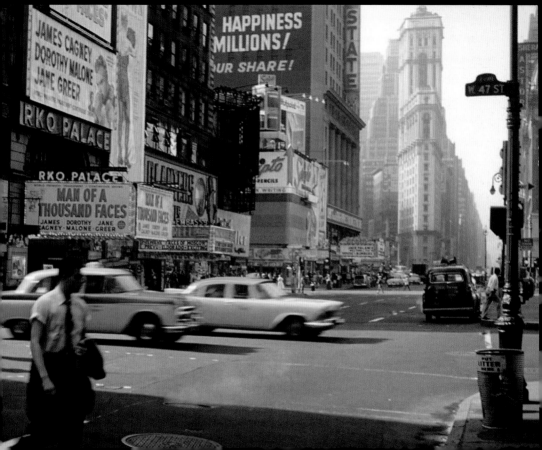

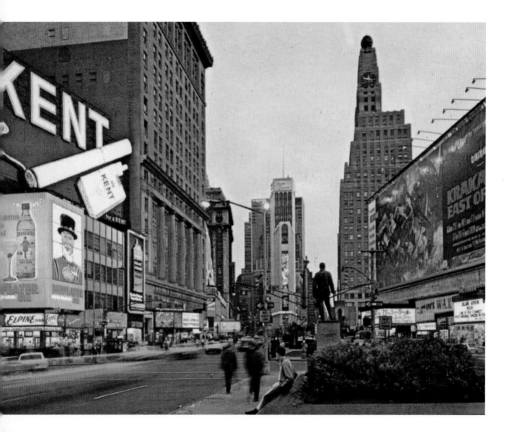

Times Square, 1969 (left) and 1955 (right)

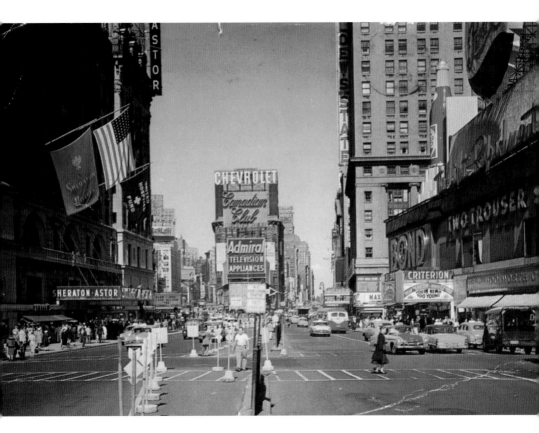

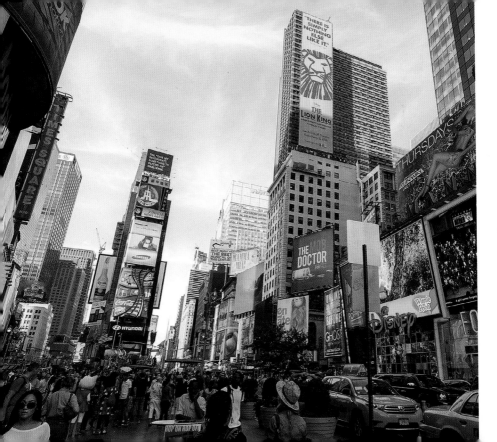

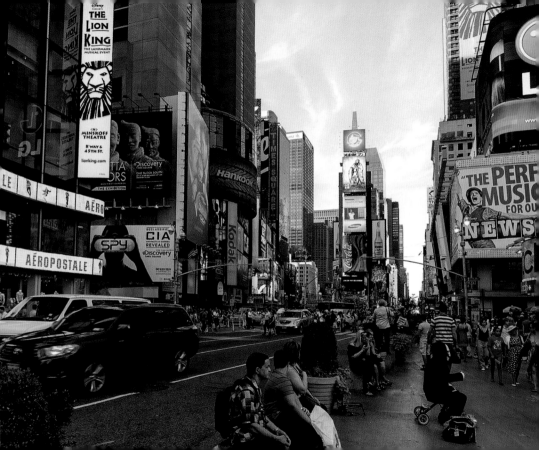

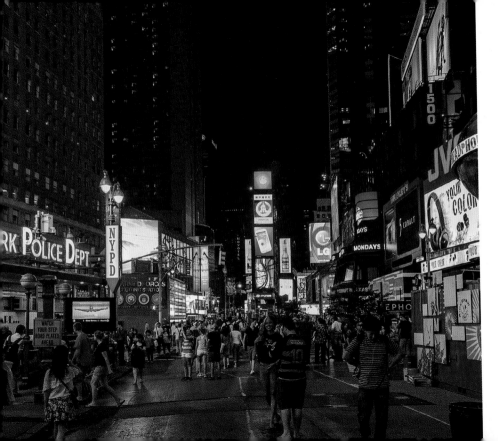

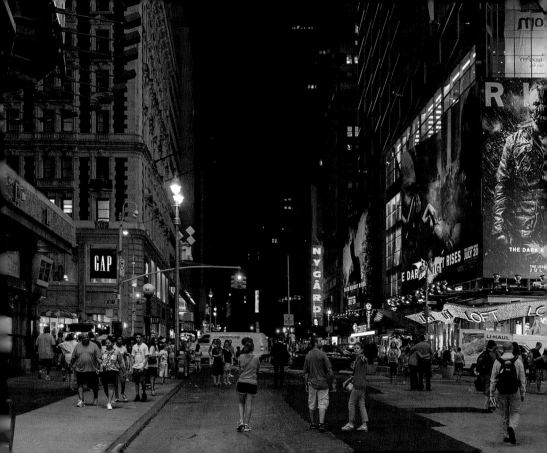

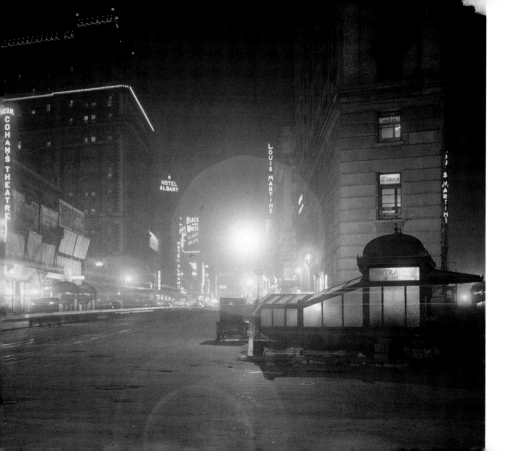

Broadway from the Times Building, c. 1915

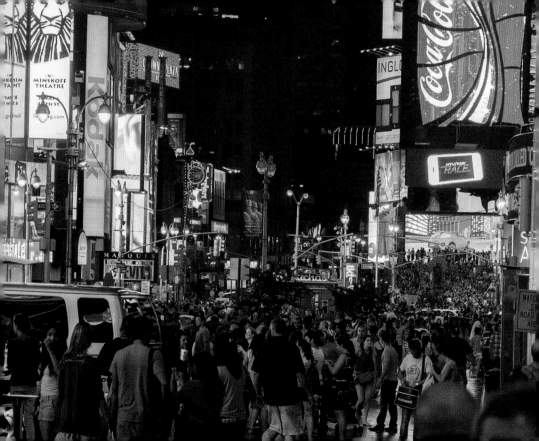

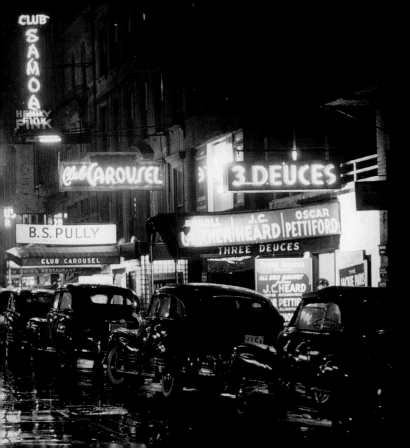

West 52nd Street, 1948

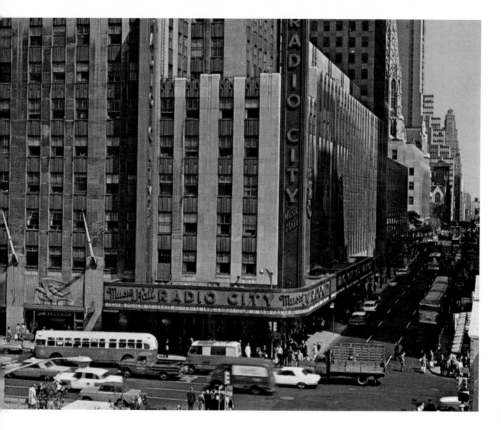

Radio City Music Hall, c. 1960

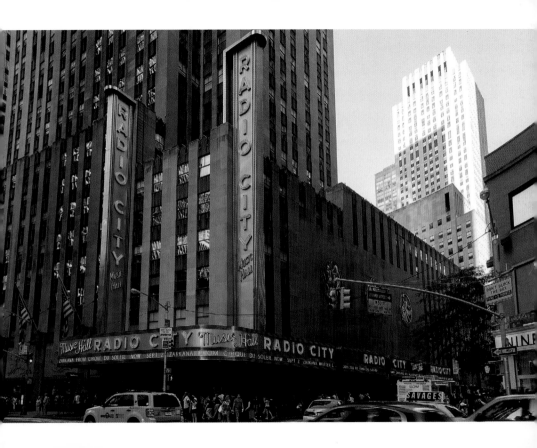

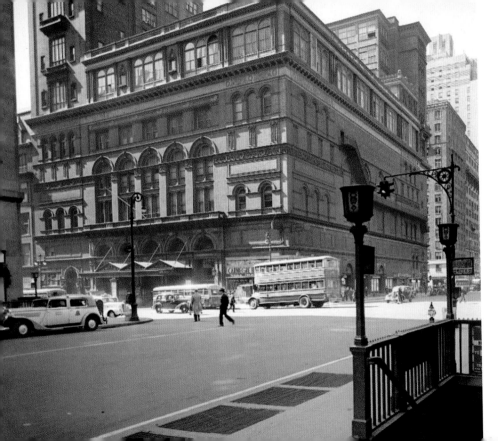

Carnegie Hall, c. 1940

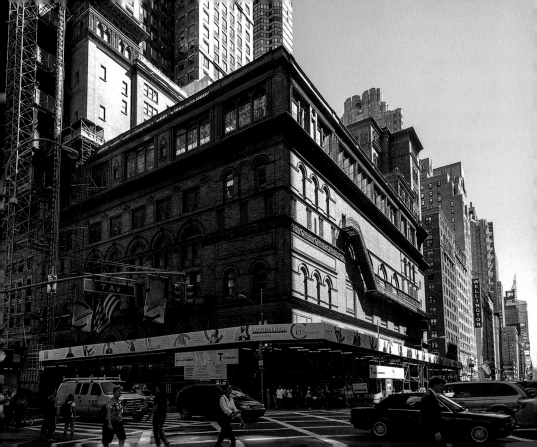

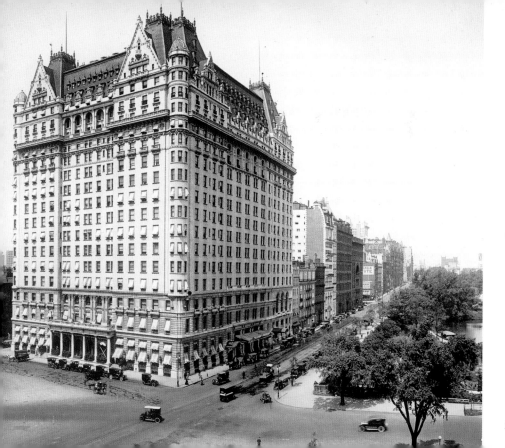

Plaza Hotel, c. 1910

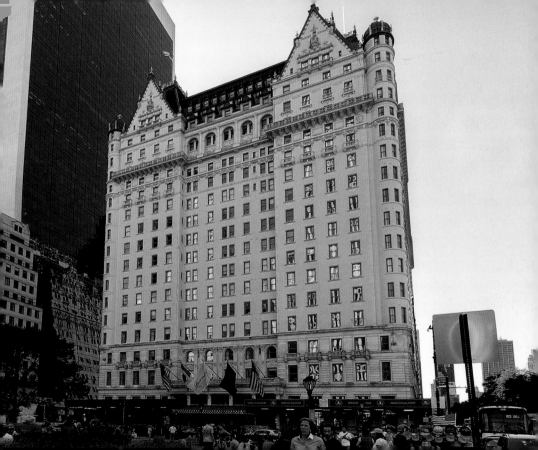

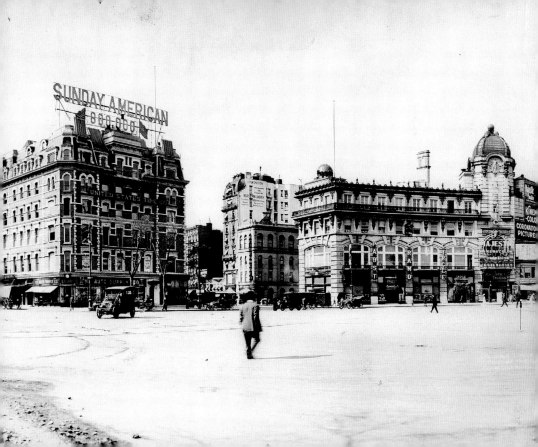

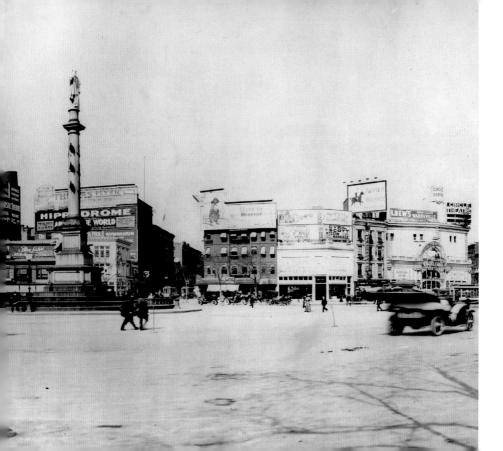

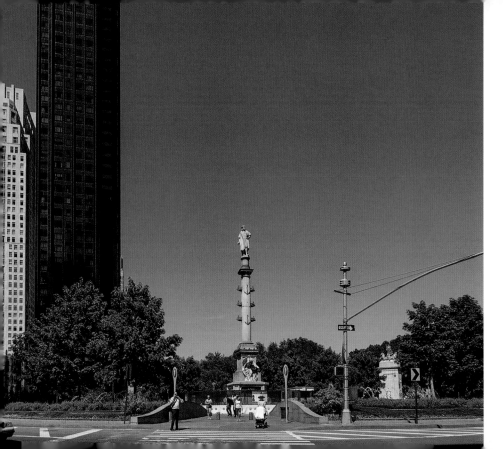

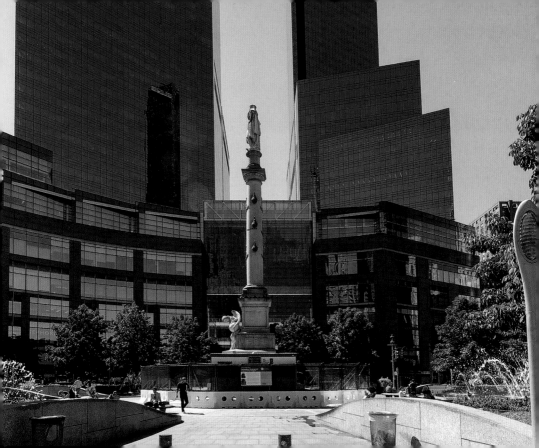

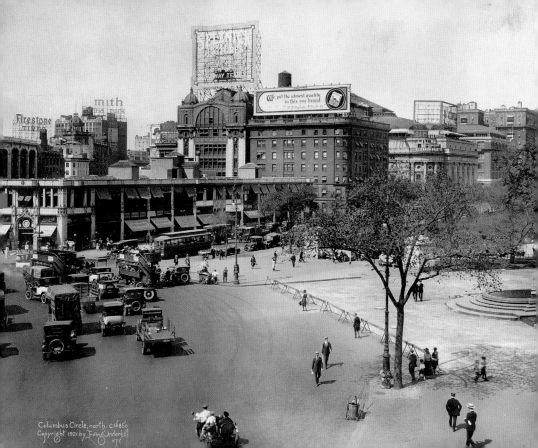

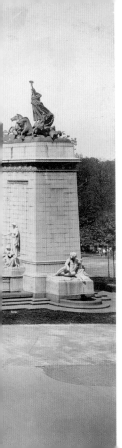

Maine Monument, Columbus Circle, 1921

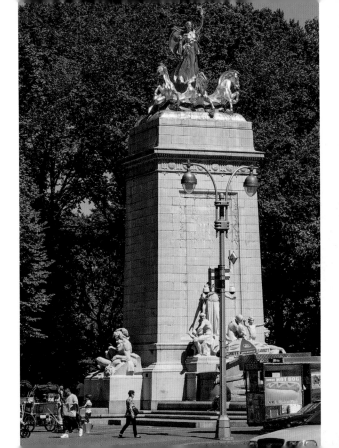

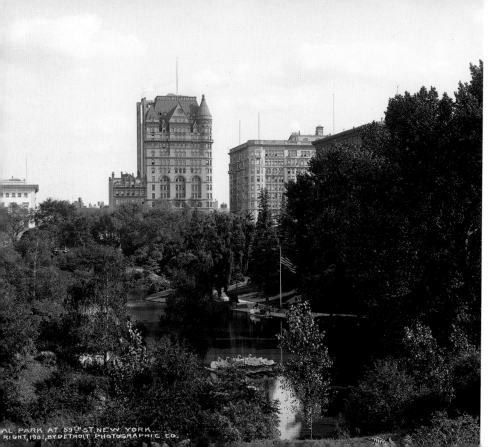

Central Park at 59th Street, 1901

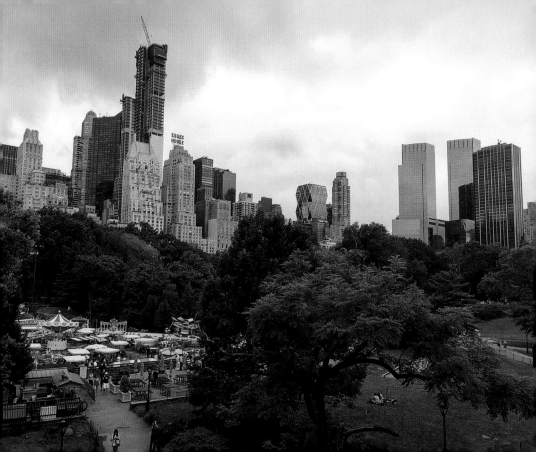

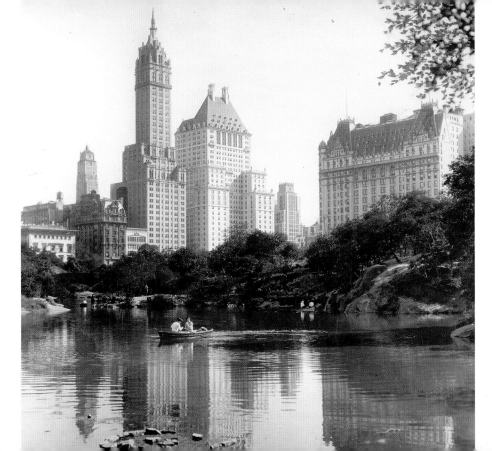

Central Park Lake, c. 1915

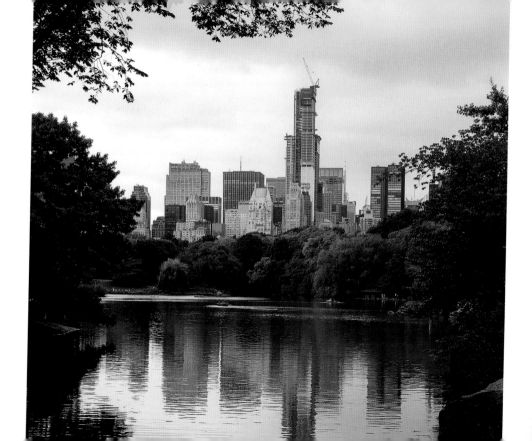

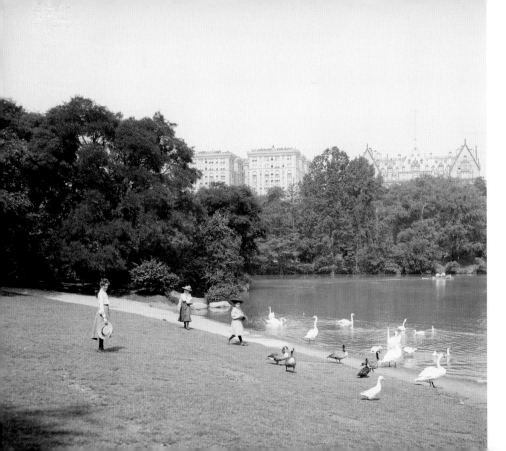

Central Park Lake, c. 1905

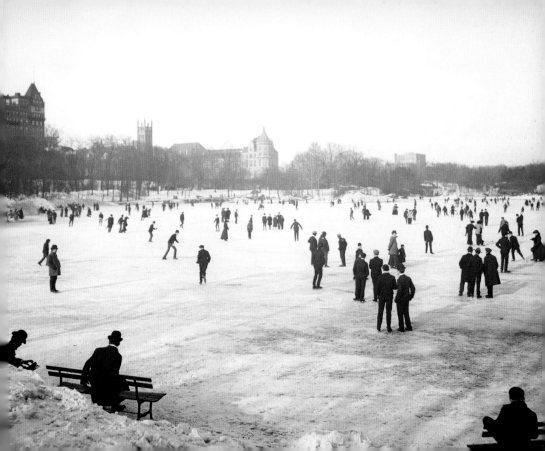

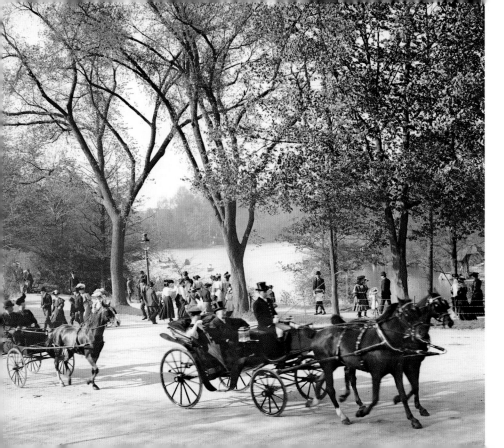

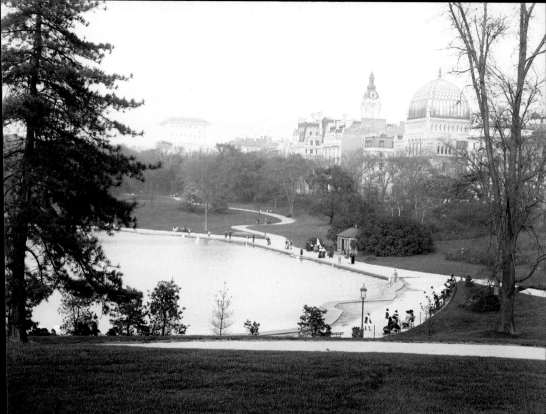

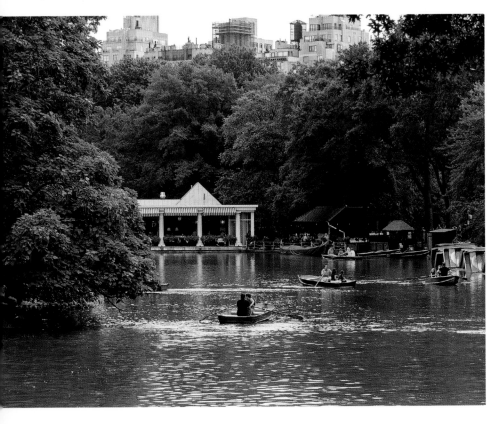

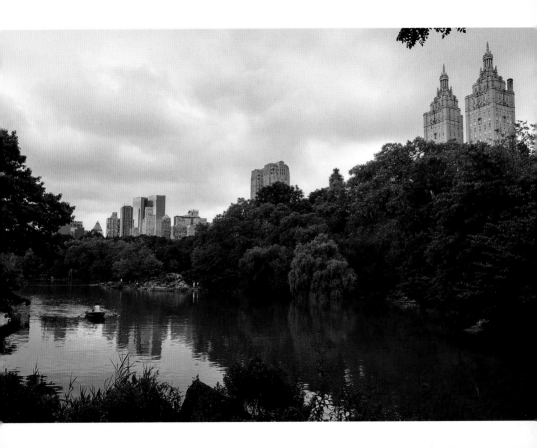

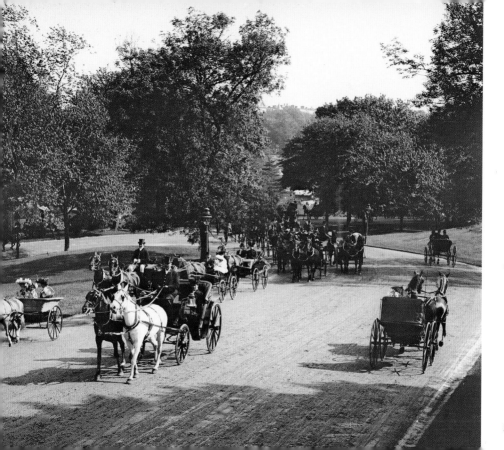

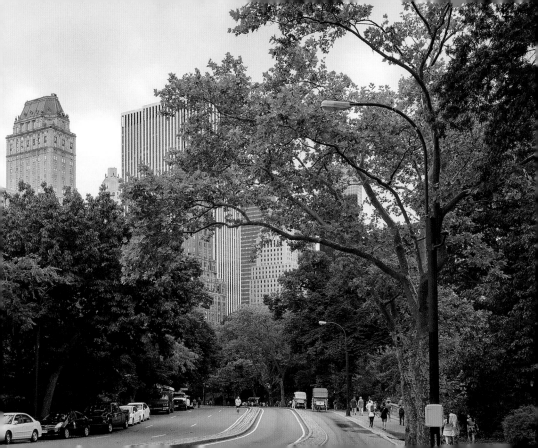

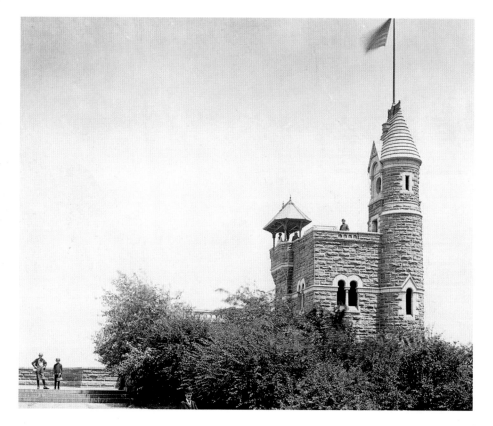

Belvedere Castle, Central Park, c. 1900

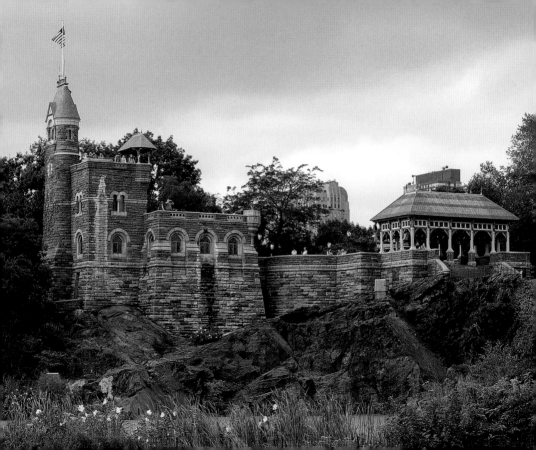

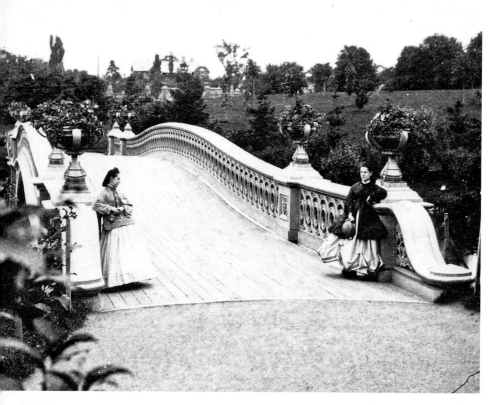

Bow Bridge, Central Park, c. 1900

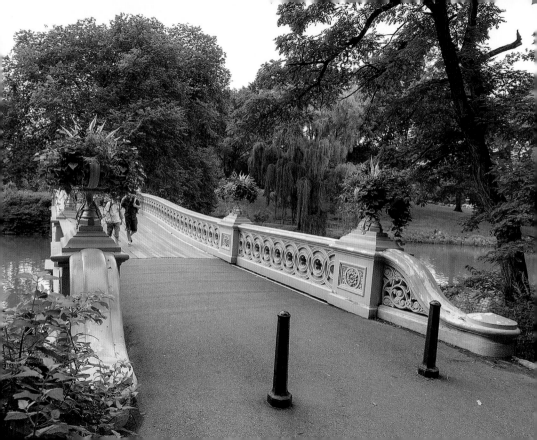

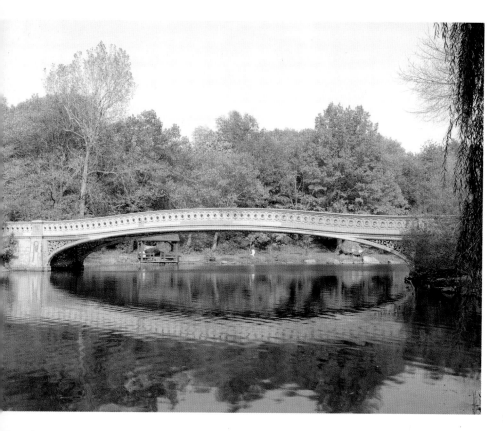

Bow Bridge, Central Park, 1984

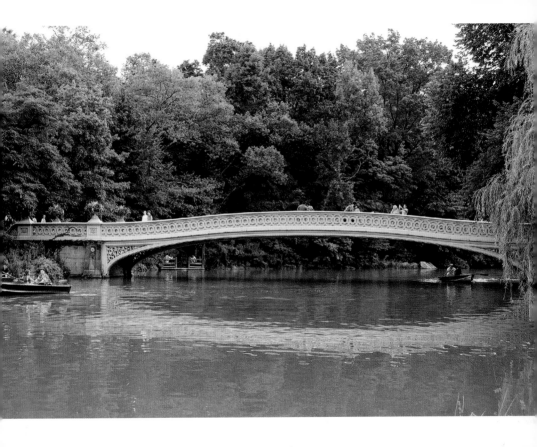

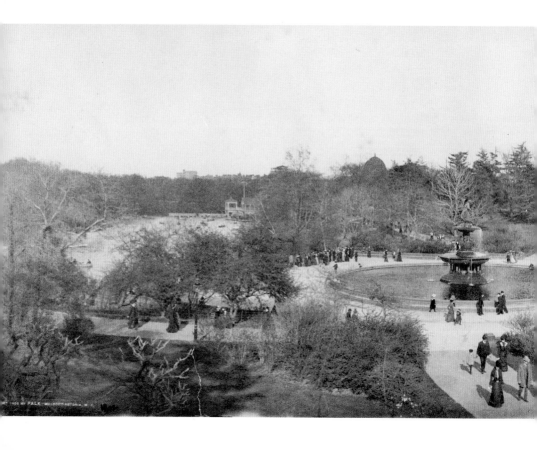

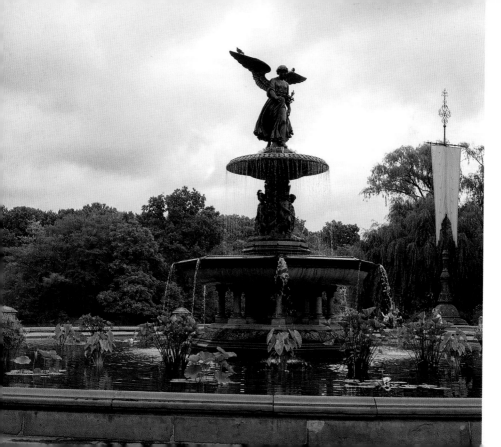

Bethesda Terrace and Fountain, Central Park

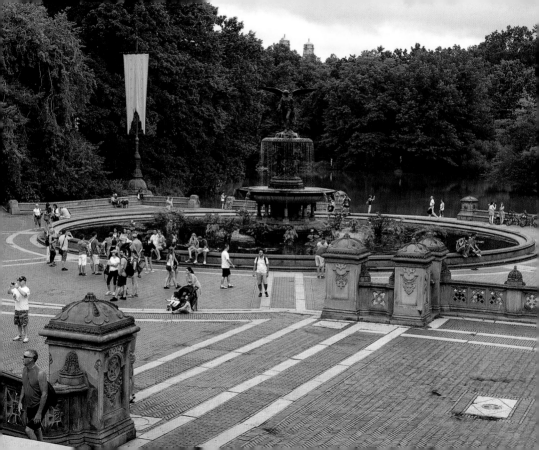

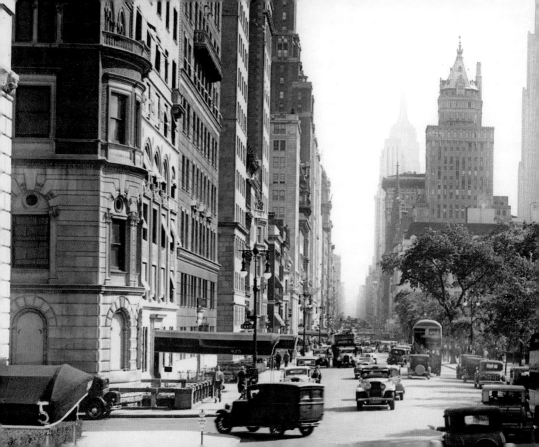

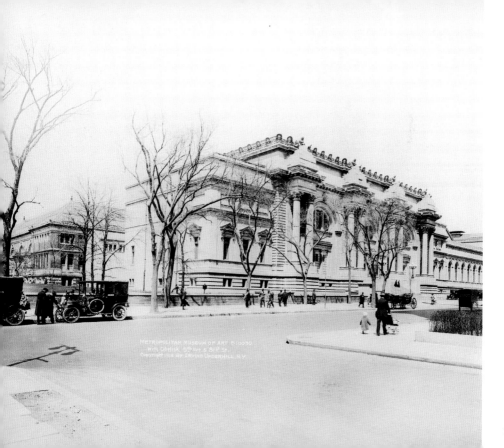

The Metropolitan Museum, 1914

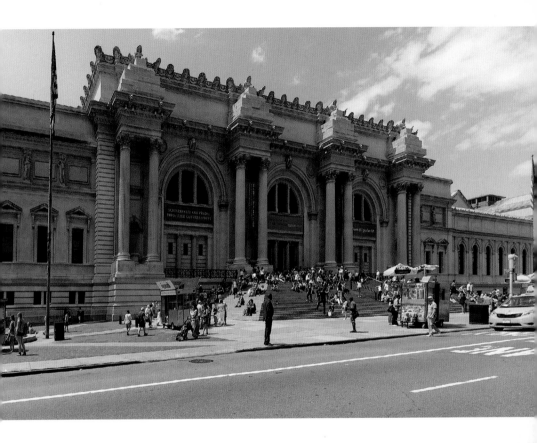

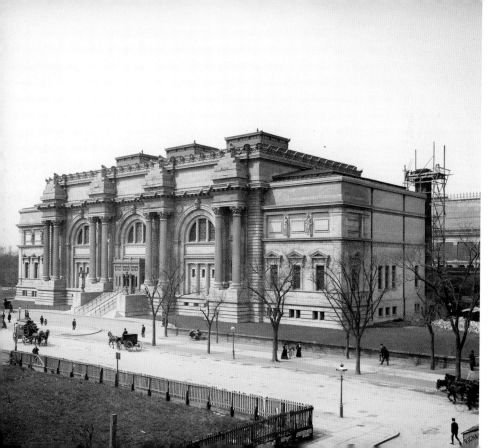

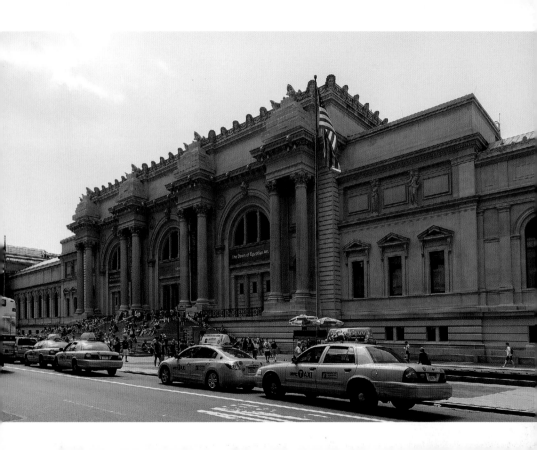

Statuary Hall (left) and Jade Room (right), The Metropolitan Museum, 1905

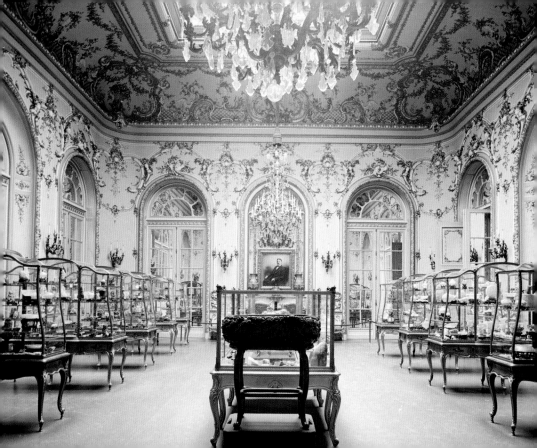

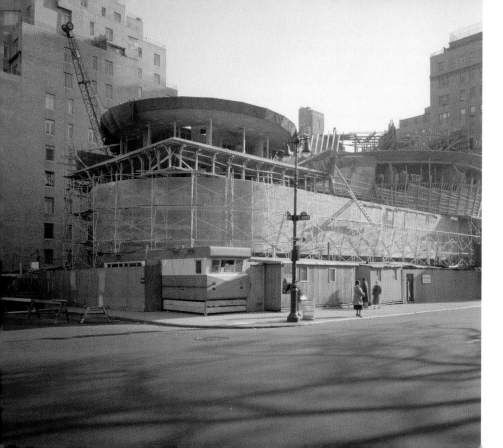

Solomon R. Guggenheim Museum under construction, 1957

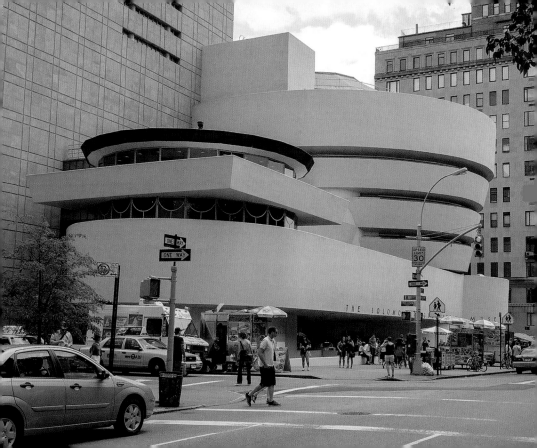

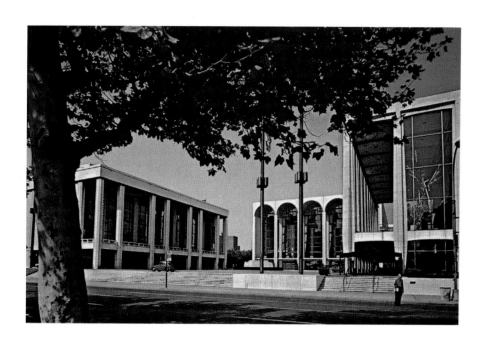

Lincoln Center, c. 1965

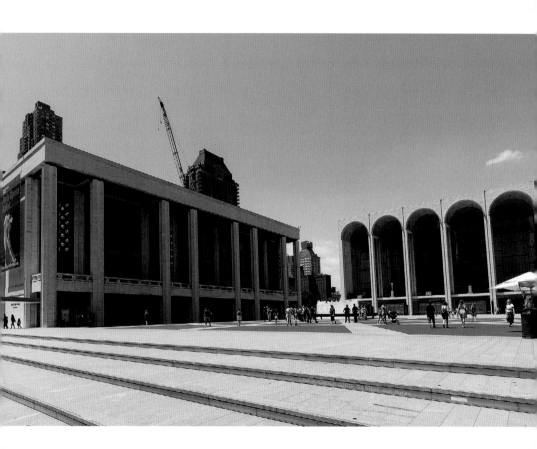

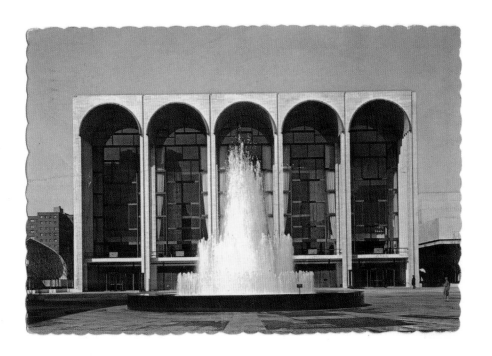

Lincoln Center, c. 1965

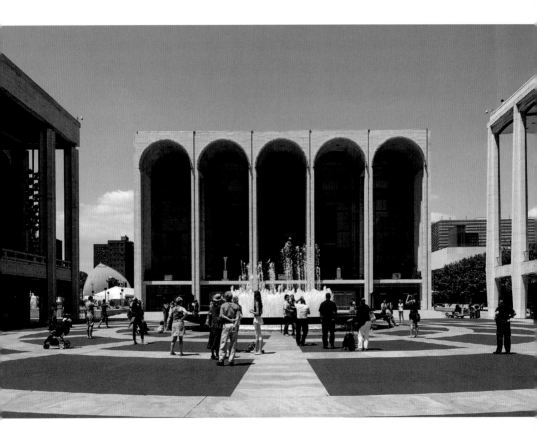

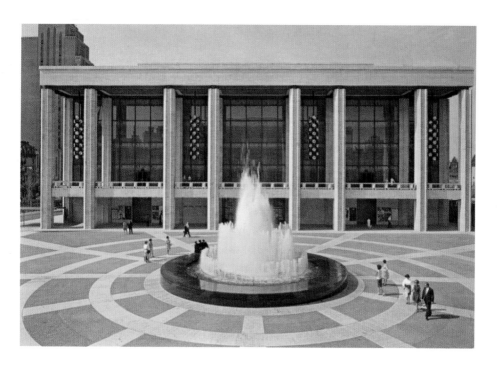

Lincoln Center, c. 1965

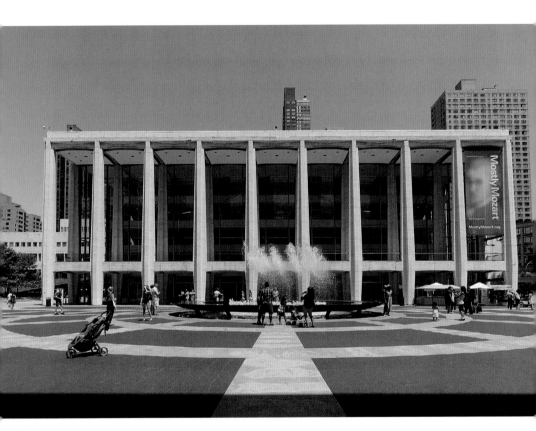

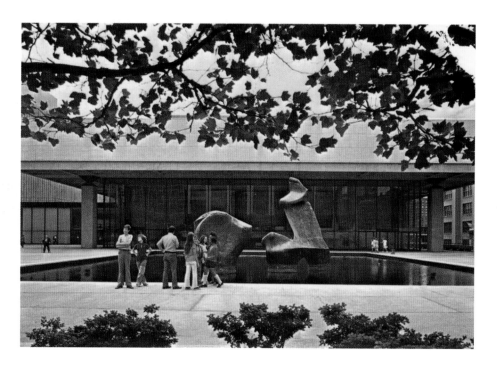

Lincoln Center, c. 1965

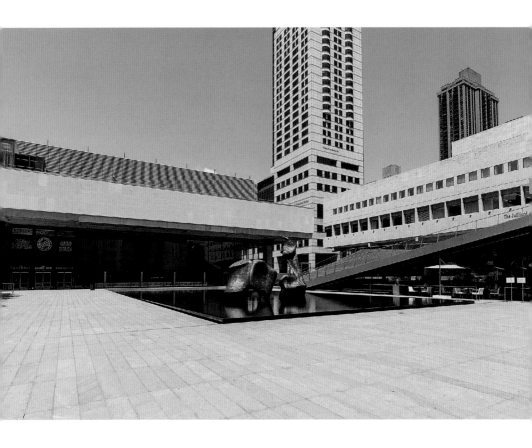

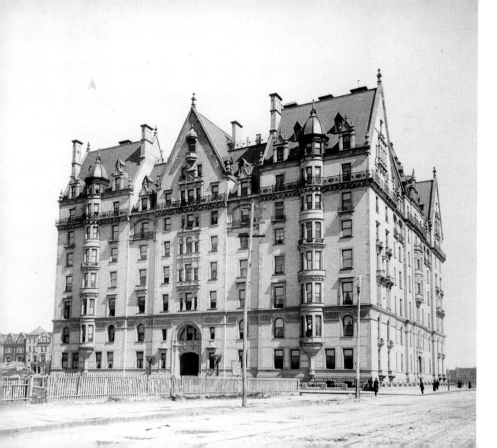

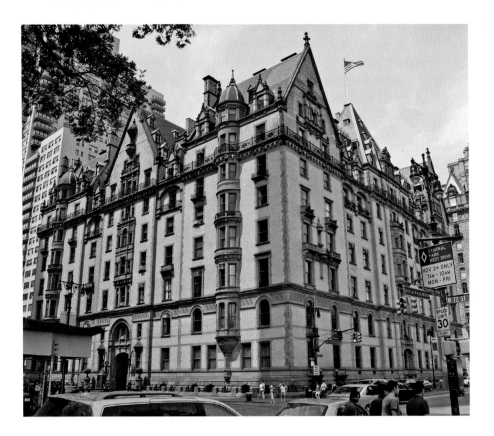

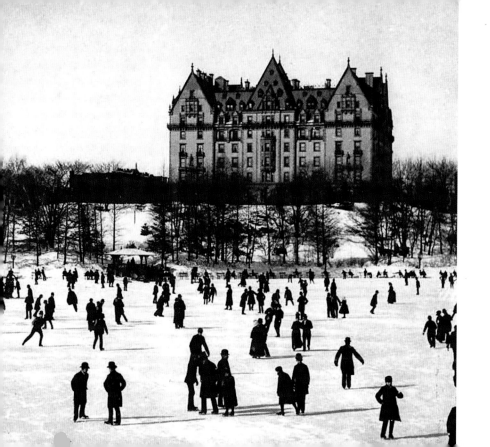

The Dakota Building from Central Park, c. 1890

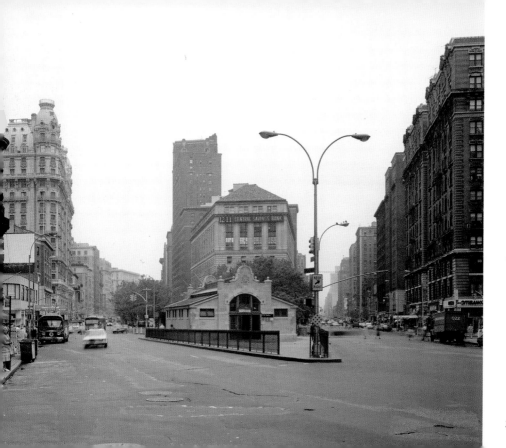

12 11 CENTRAL SAVINGS BANK

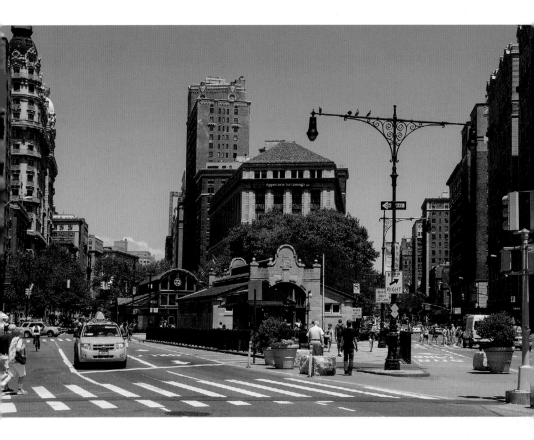

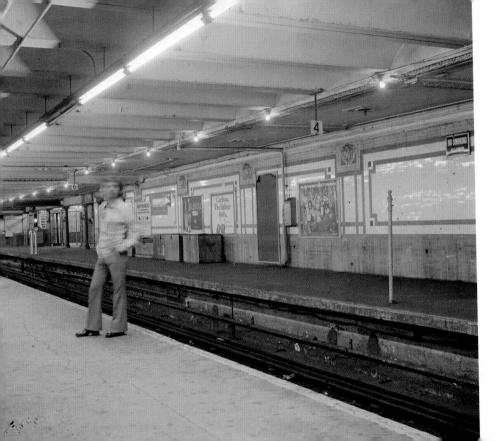

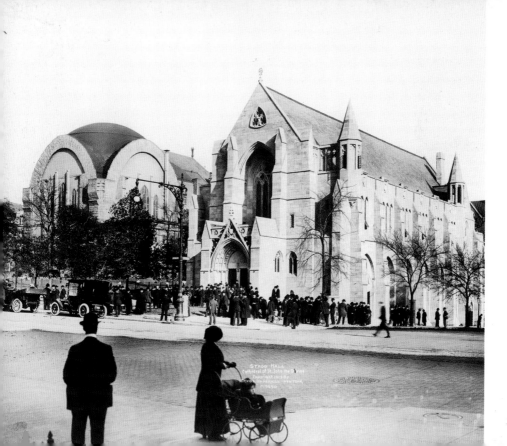

Cathedral of St. John the Divine, 1913

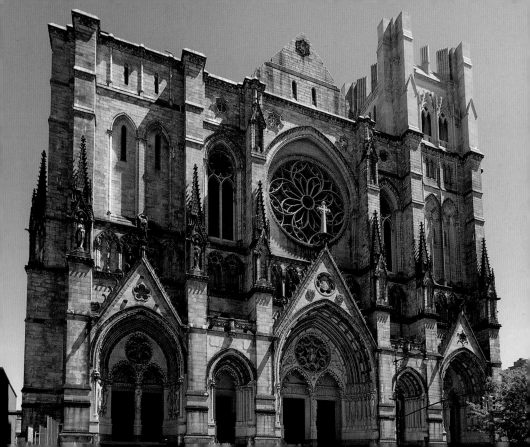

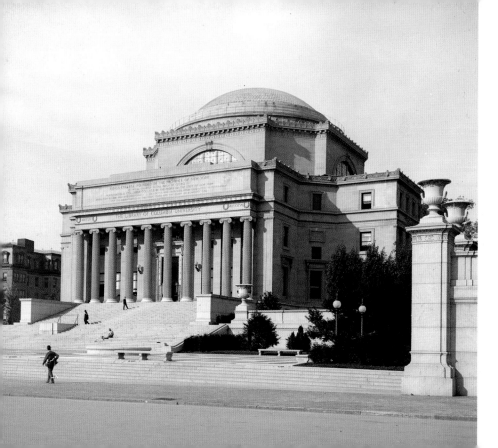

Columbia University Library, 1901

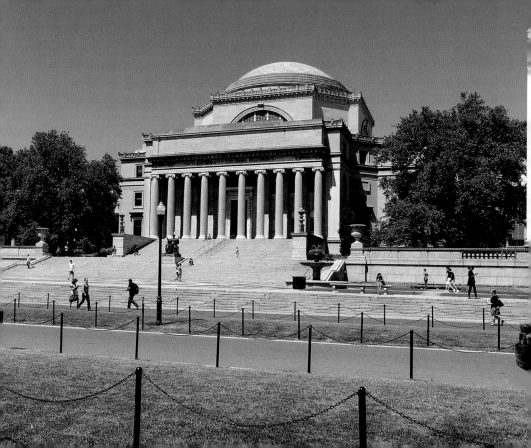

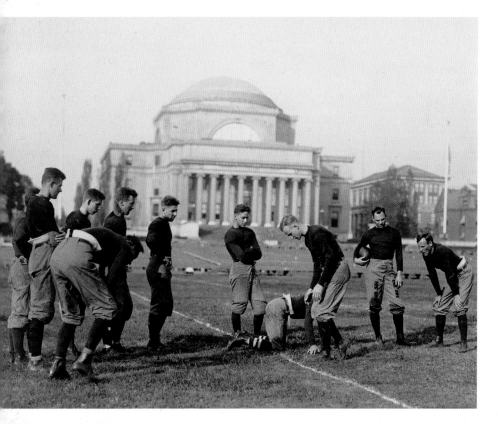

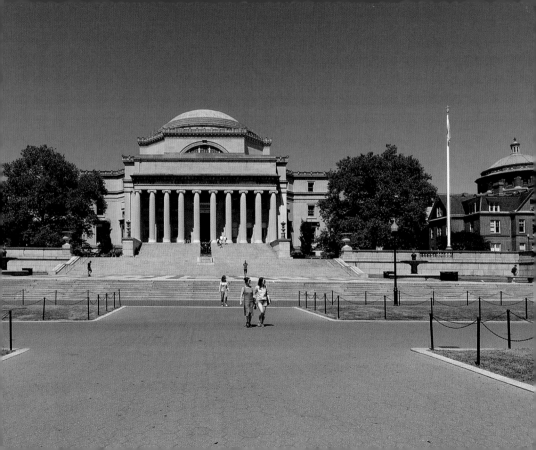

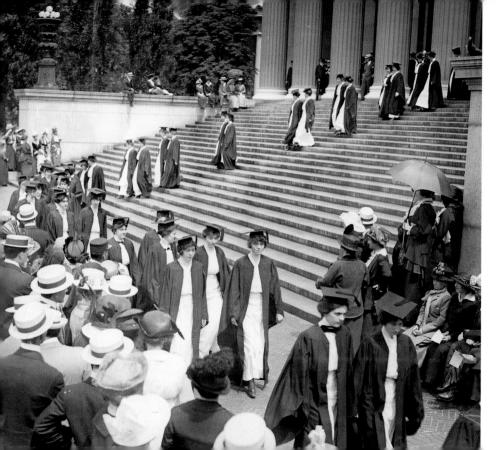

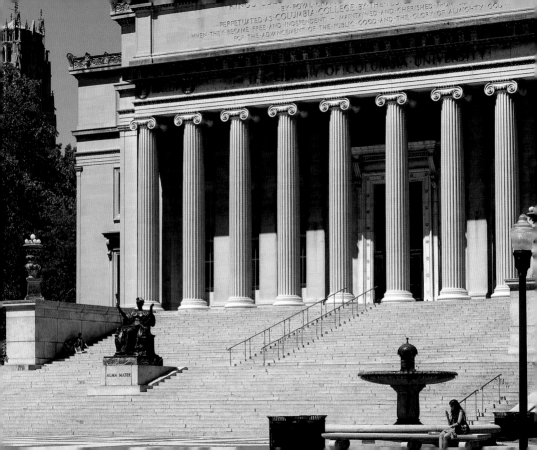

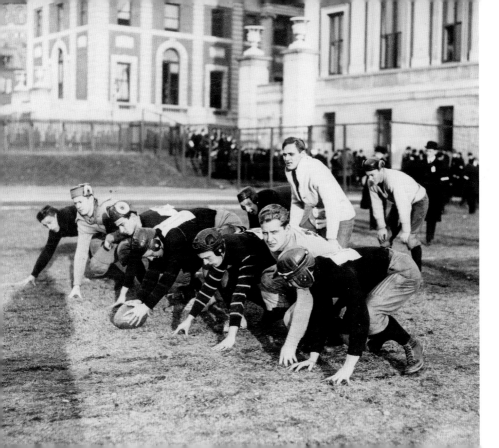

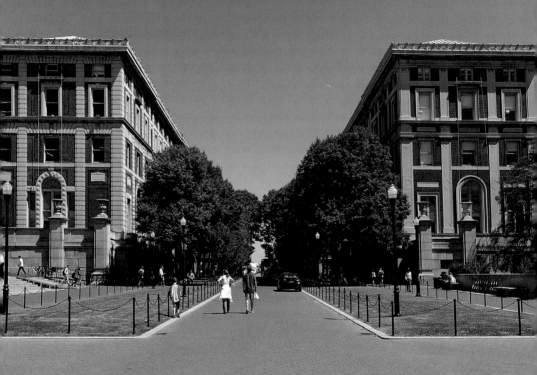

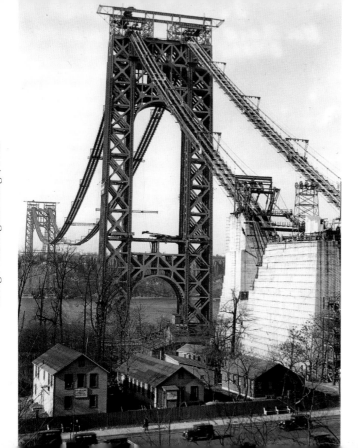

George Washington Bridge, 1930

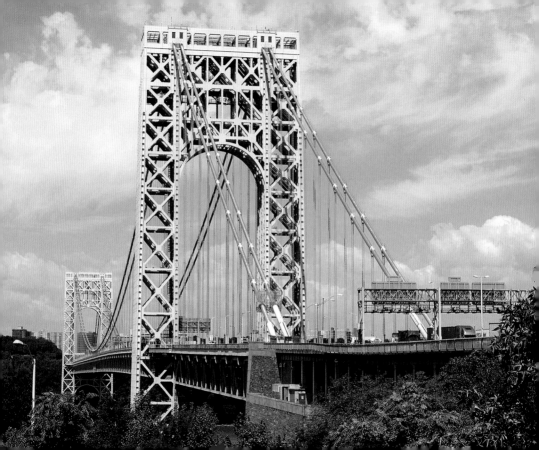

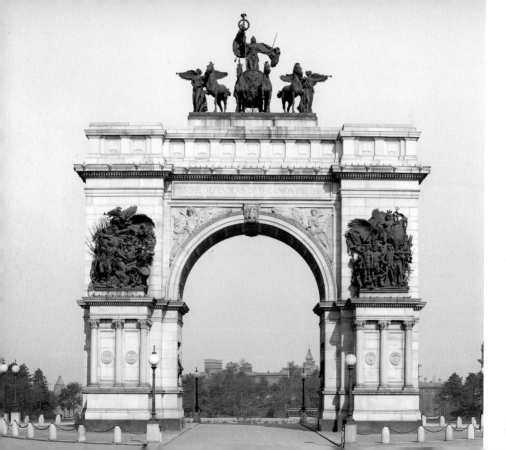

TO THE DEFENDERS OF THE UNION 1861 1865

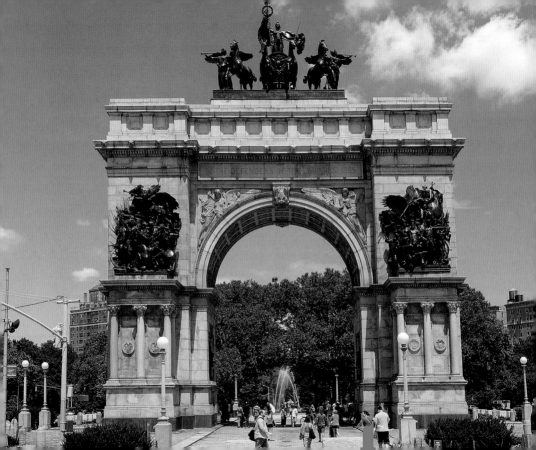

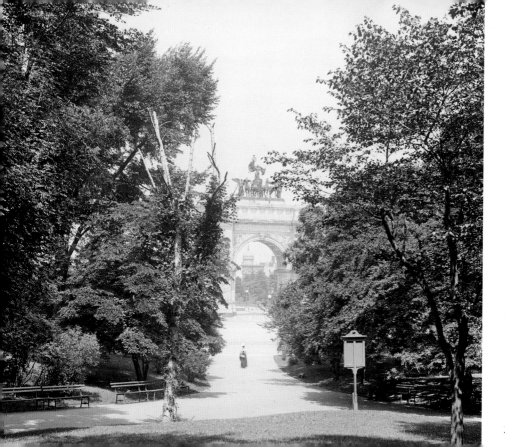

Memorial Arch from Prospect Park, Brooklyn, c. 1900

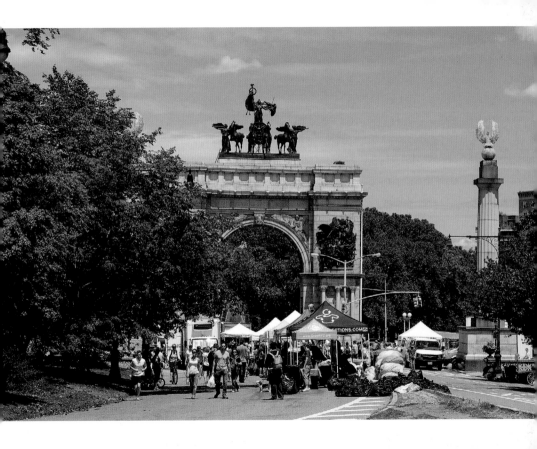

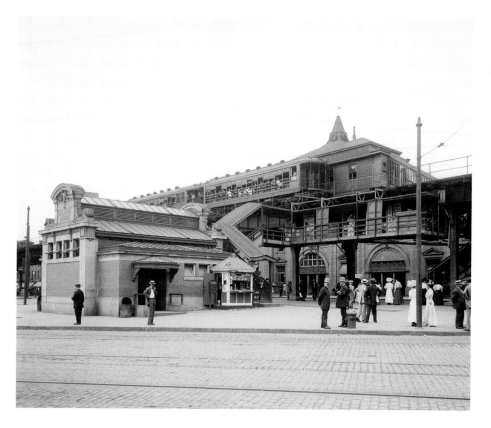

Atlantic Avenue Station, Brooklyn, c. 1915

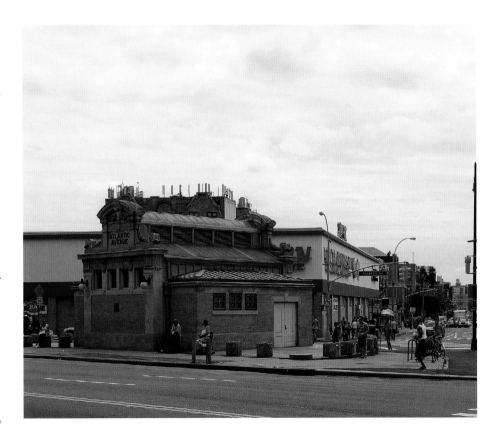

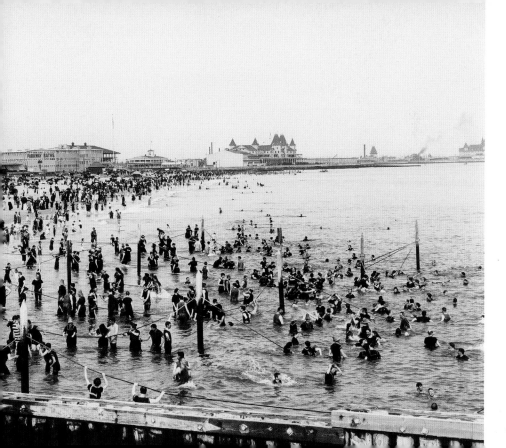

Coney Island, Brooklyn, c. 1900

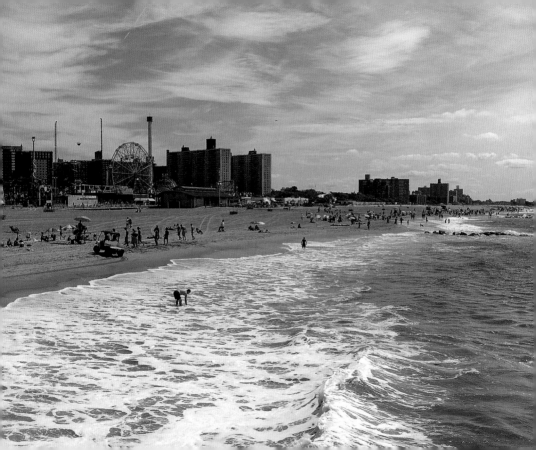

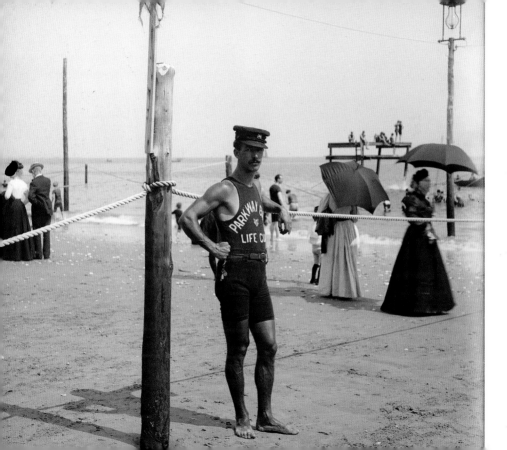

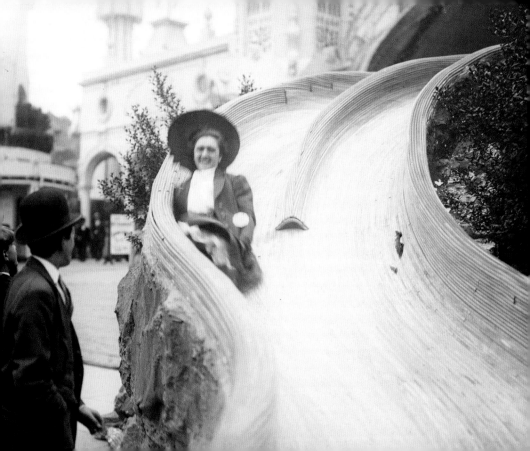

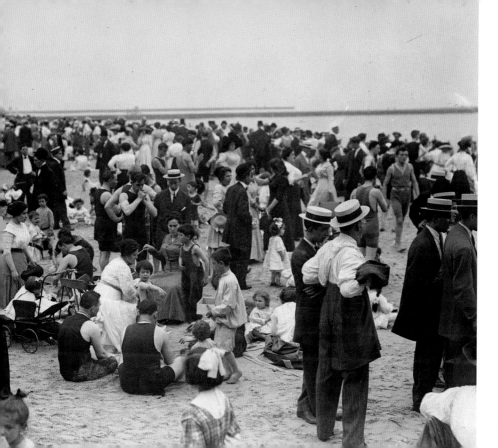

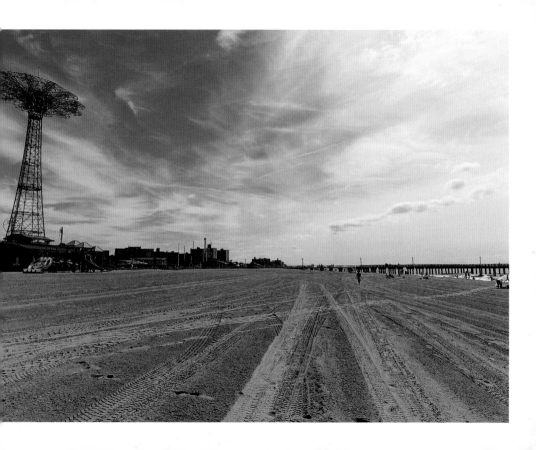

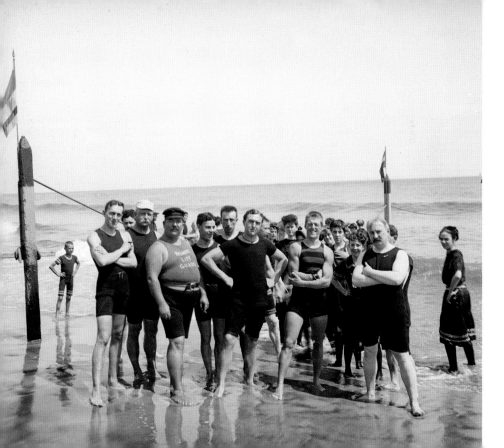

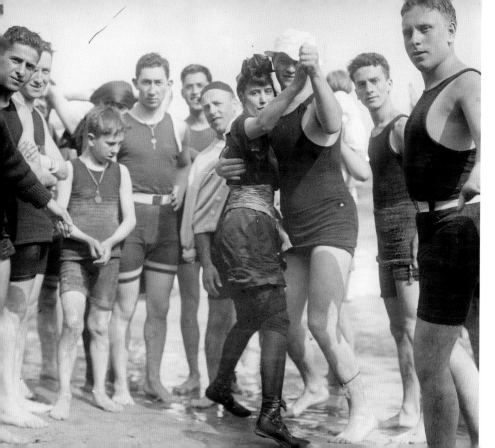

Coney Island, Brooklyn, c. 1910 (left) and 1905 (right)

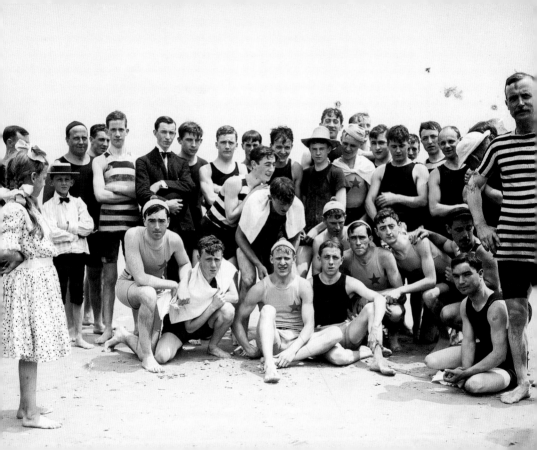

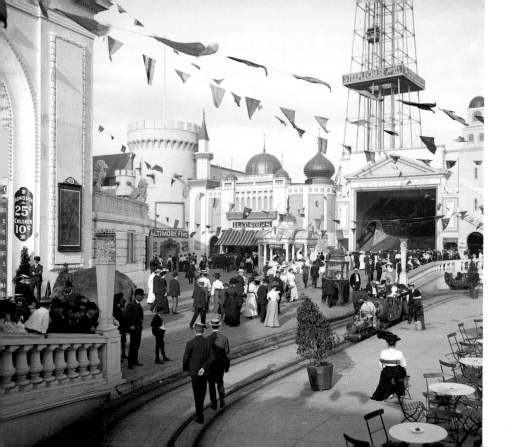

Coney Island, Brooklyn, c. 1905

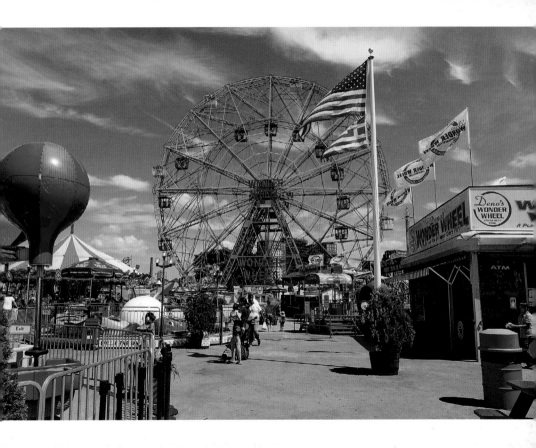

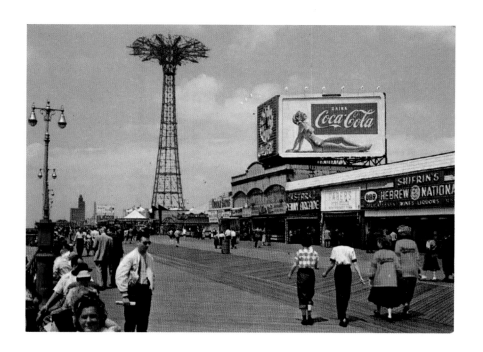

Parachute Jump from Boardwalk, Coney Island, Brooklyn, c. 1960

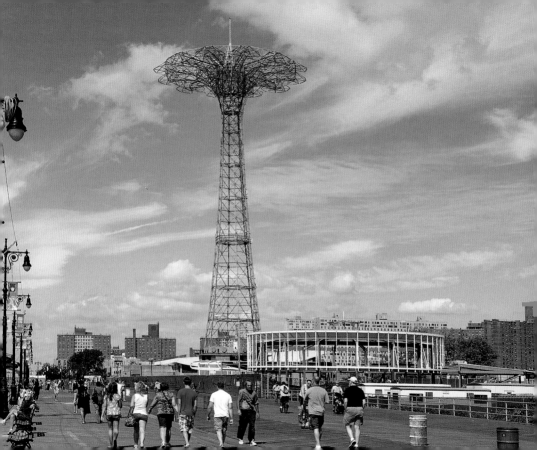

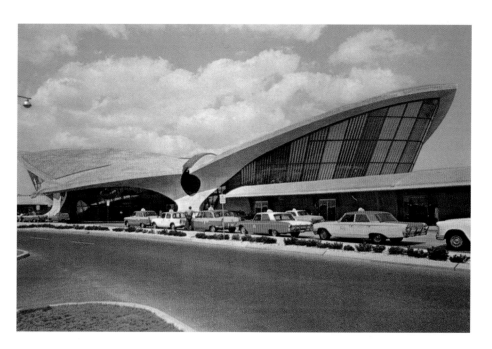

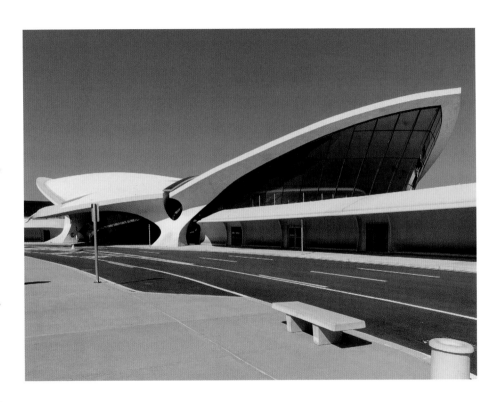

JetBlue Terminal, JFK Airport, Queens

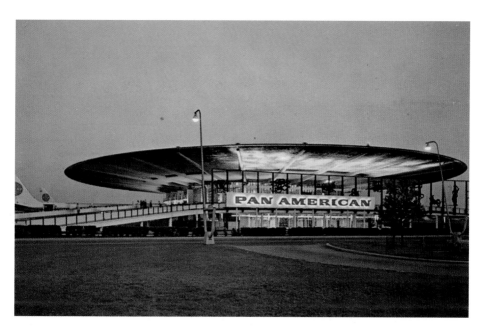

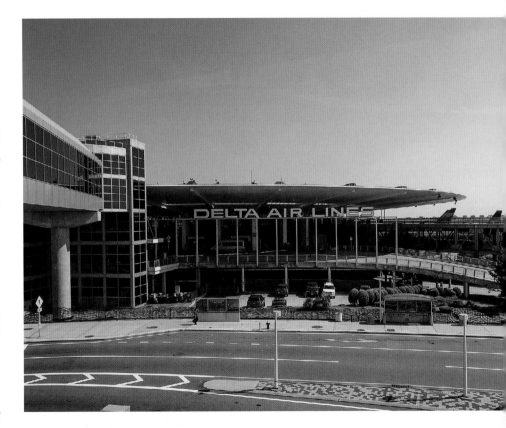

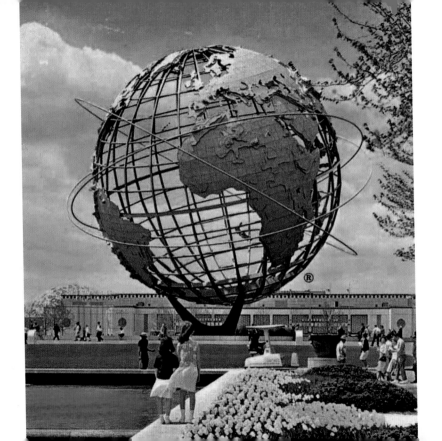

The Unisphere, Flushing Meadows, Queens, 1965

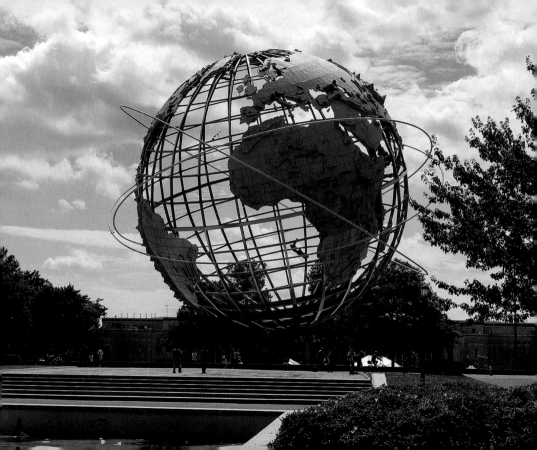

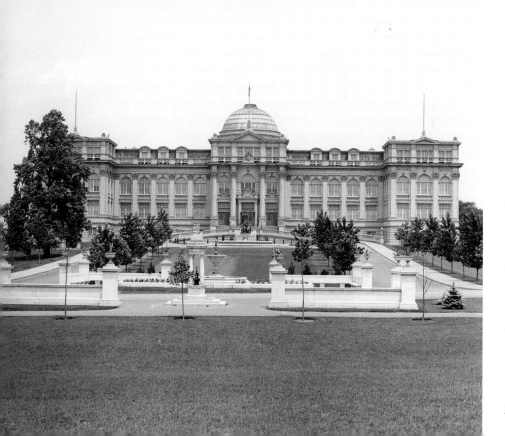

Botanical Gardens Museum, Bronx Park, The Bronx, 1906

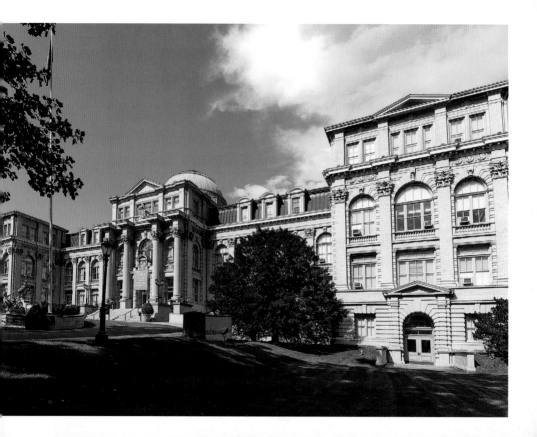

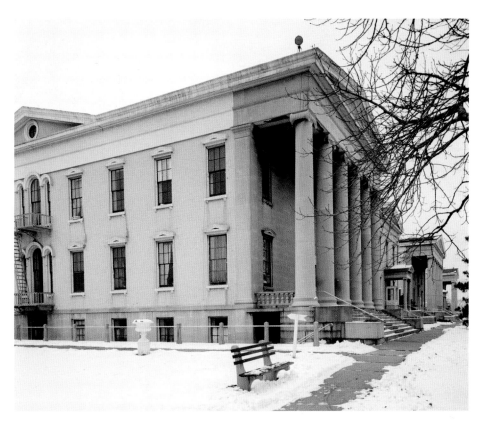

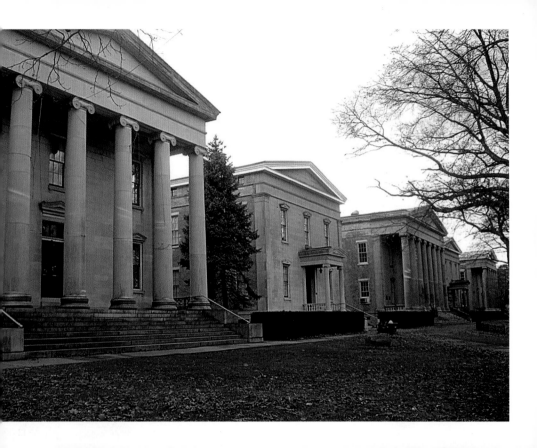

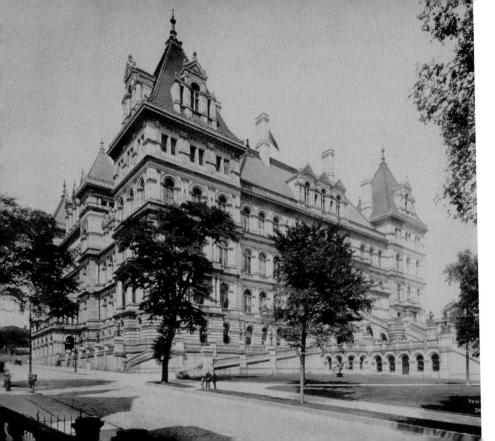

New York State Capitol, Albany, c. 1913

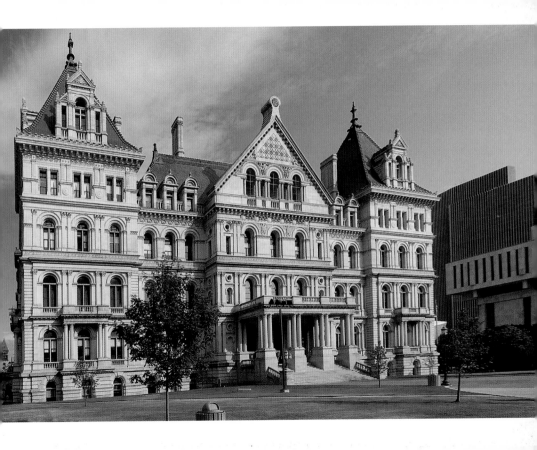

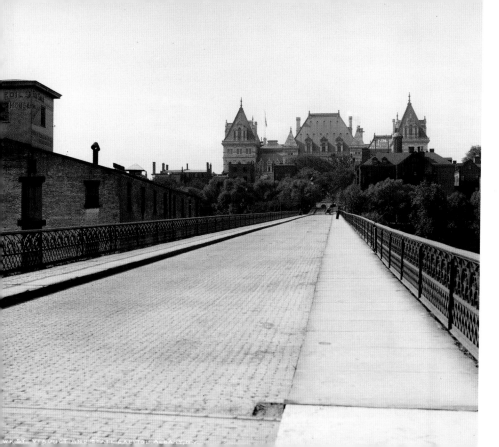

Hawk Street Viaduct and New York State Capitol, Albany, c. 1910

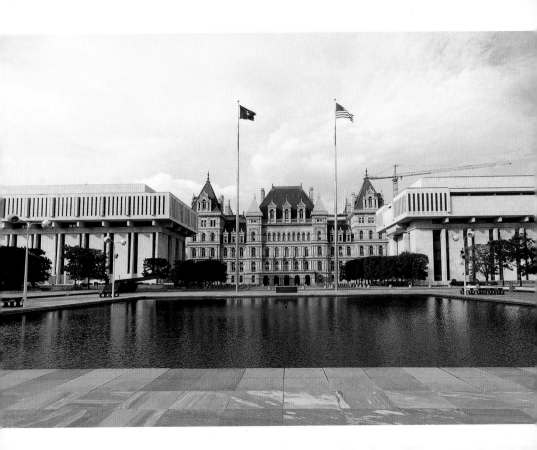

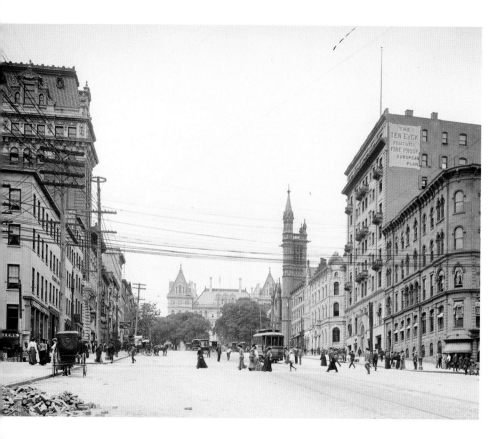

State Street, Albany, c. 1904

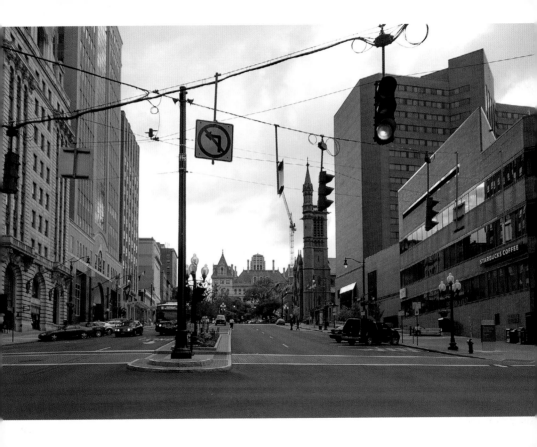

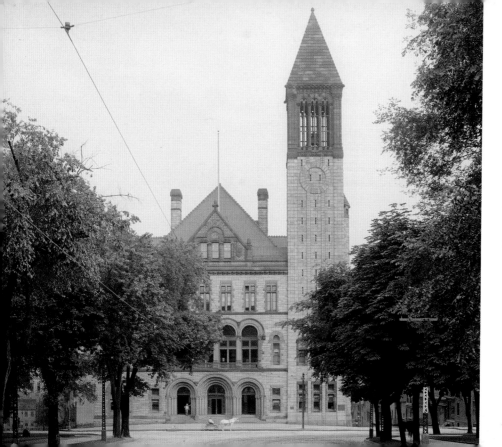

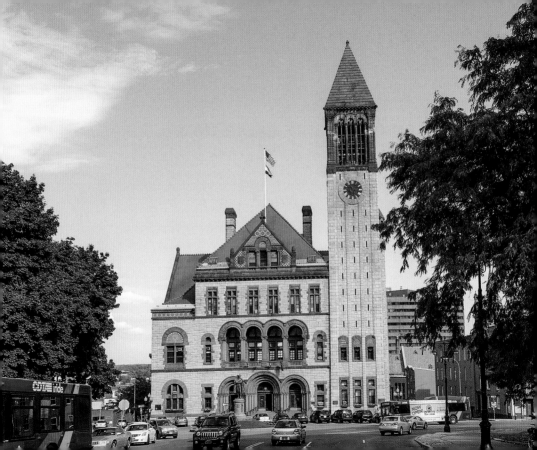

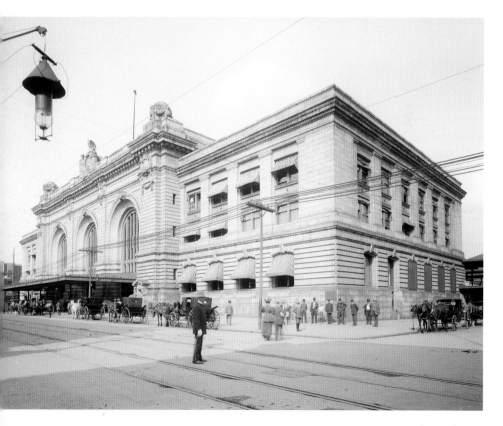

Union Station, Albany, c. 1910

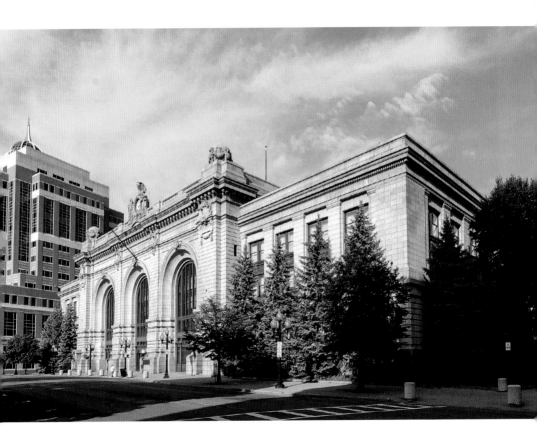

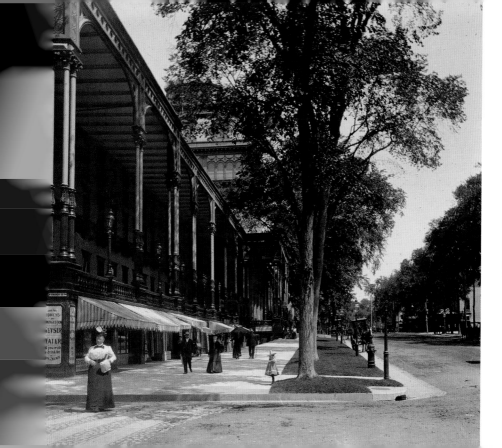

Broadway, Saratoga Springs, c. 1910

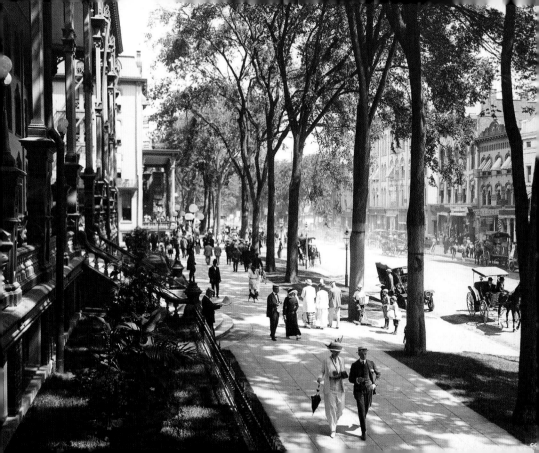

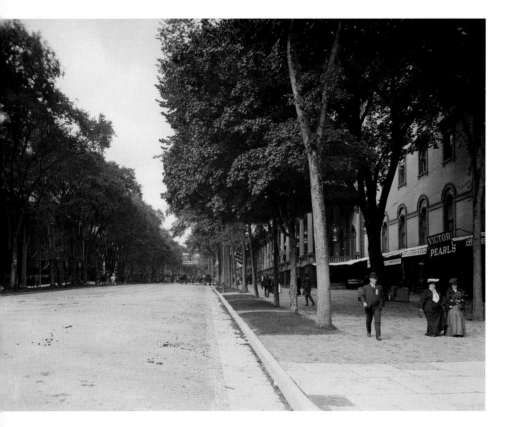

Broadway, Saratoga Springs, c. 1910

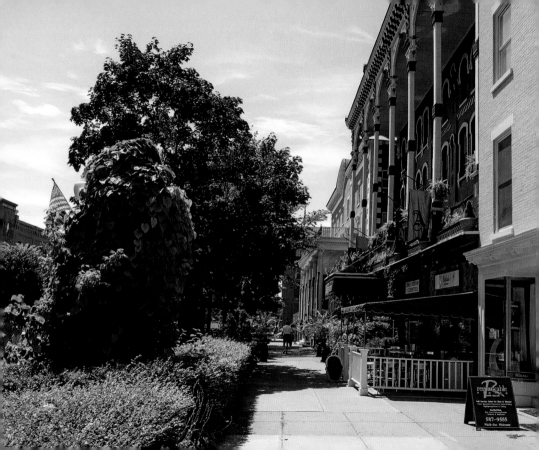

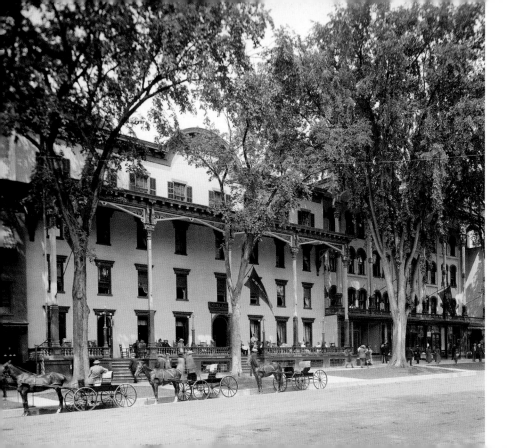

American and Adelphi Hotels, Saratoga Springs, c. 1910

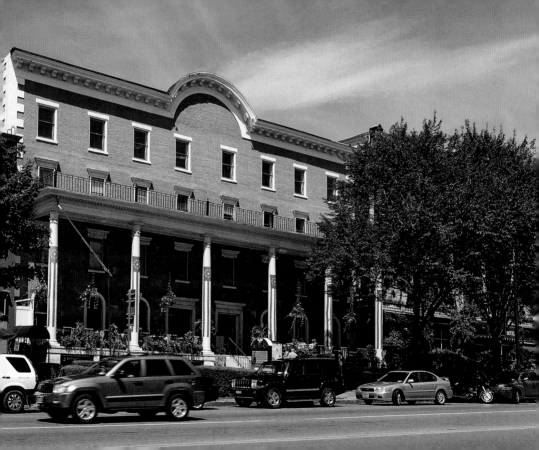

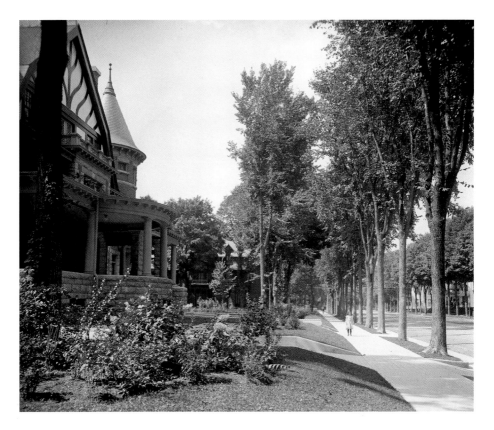

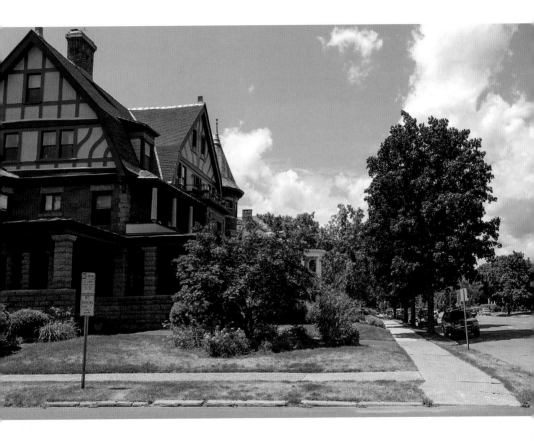

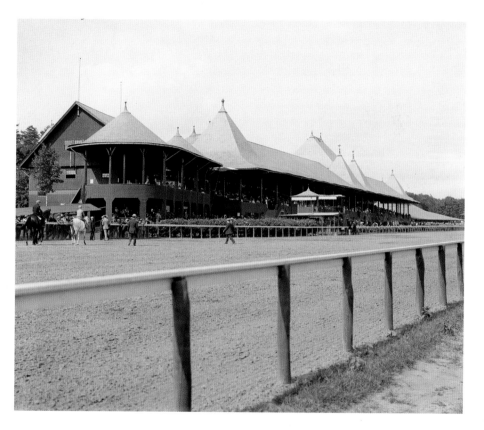

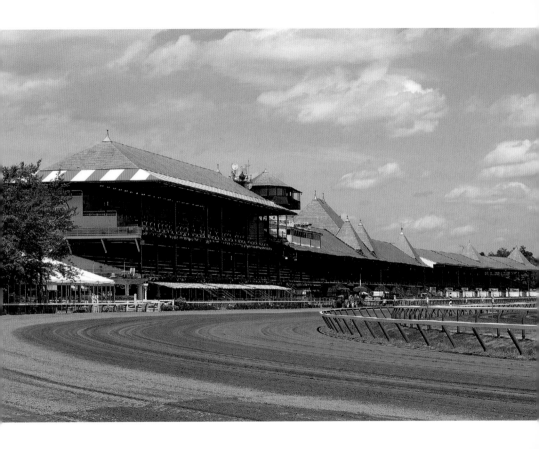

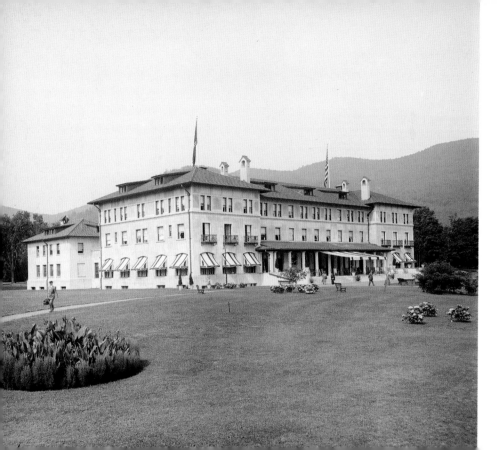

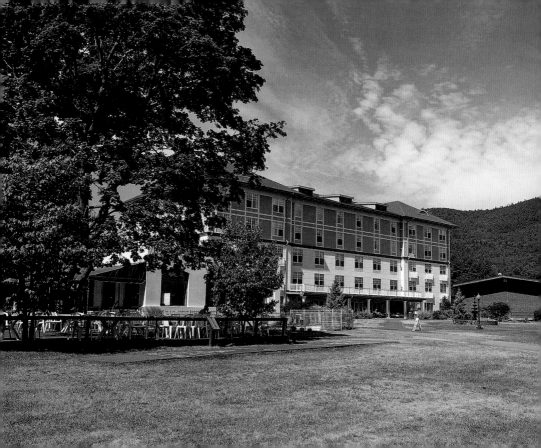

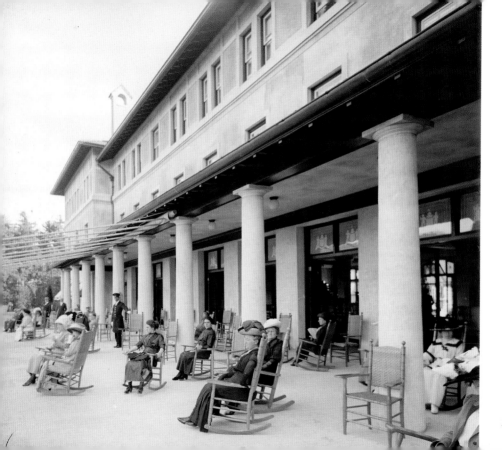

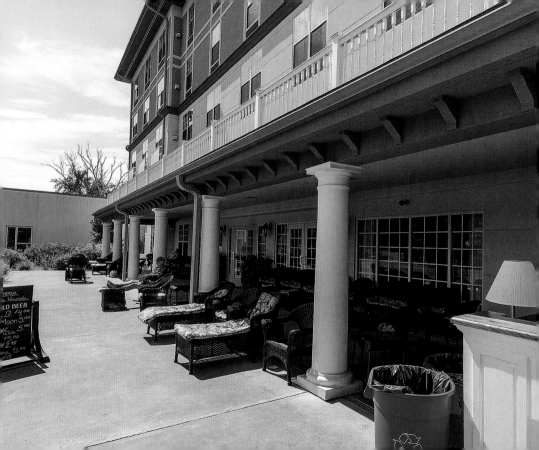

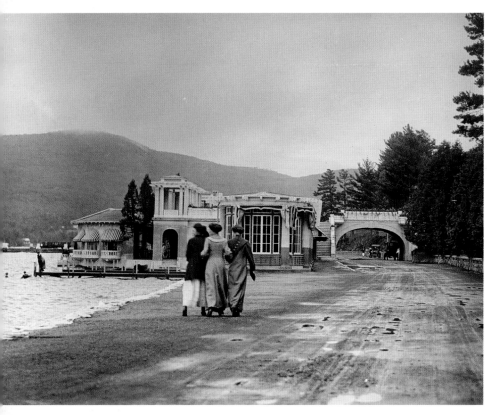

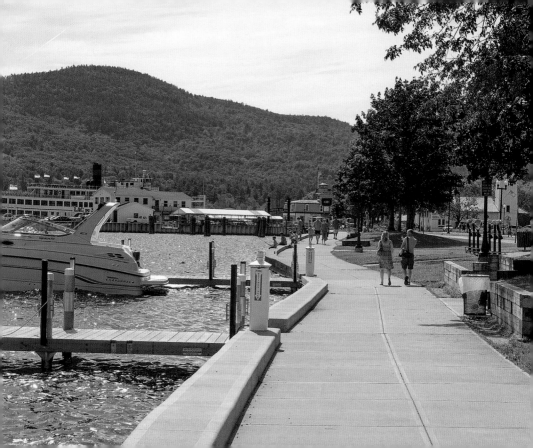

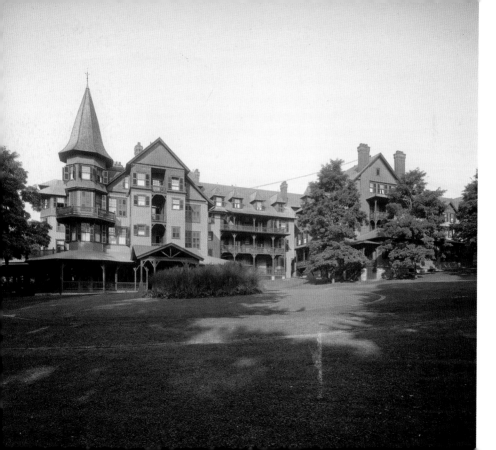

The First Sagamore Hotel, Green Island, Lake George, 1907

The First Sagamore Hotel, Green Island, Lake George, 1907

The First Sagamore Hotel, Green Island, Lake George, 1907

The First Sagamore Hotel, Green Island, Lake George, 1907

The First Sagamore Hotel, Green Island, Lake George, 1907

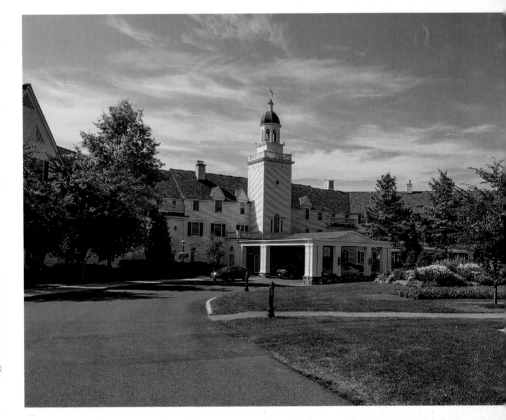

Sagamore Hotel (rebuilt after 1914 fire), Green Island, Lake George

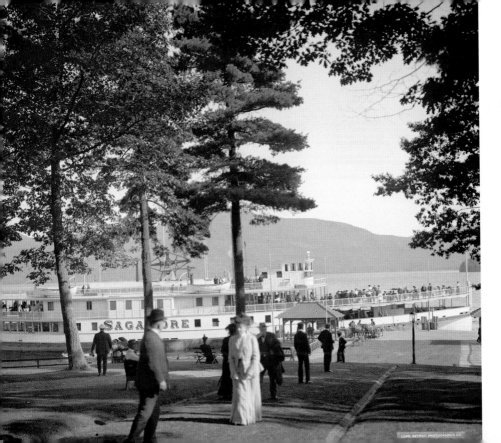

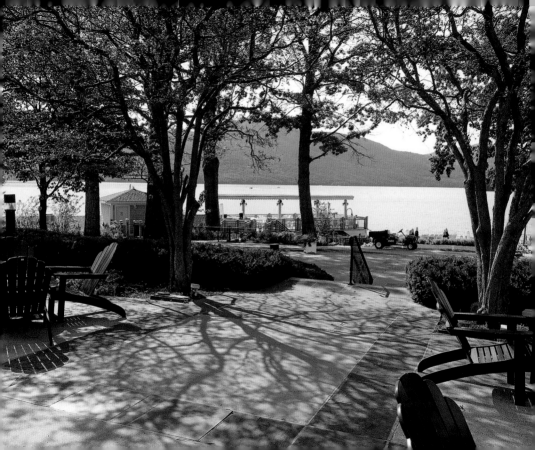

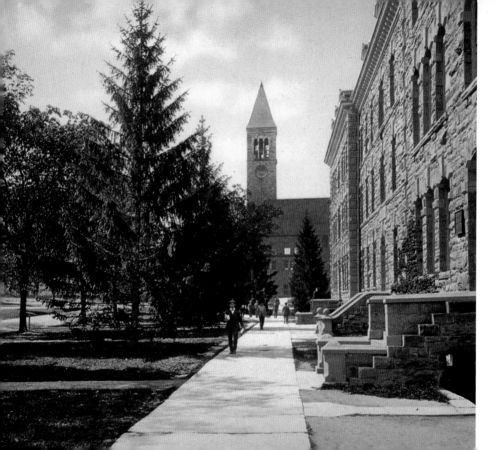

Morrill Hall and McGraw Tower, Cornell University, Ithaca, c. 1900

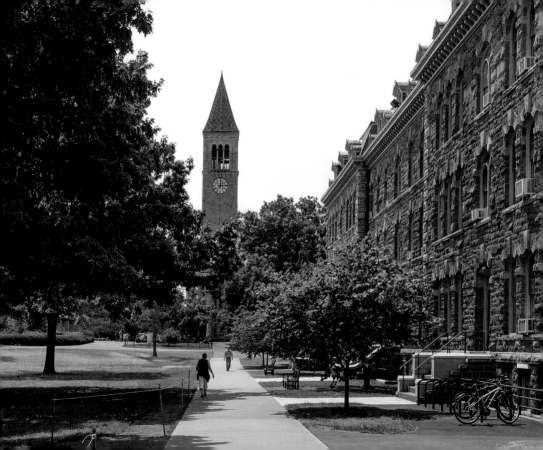

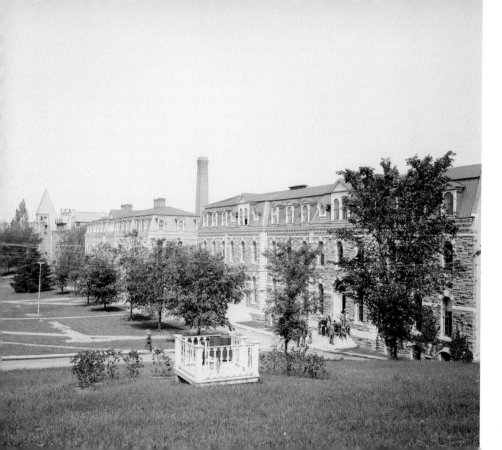

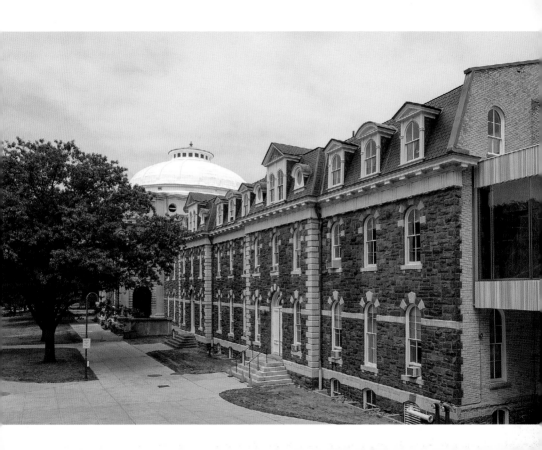

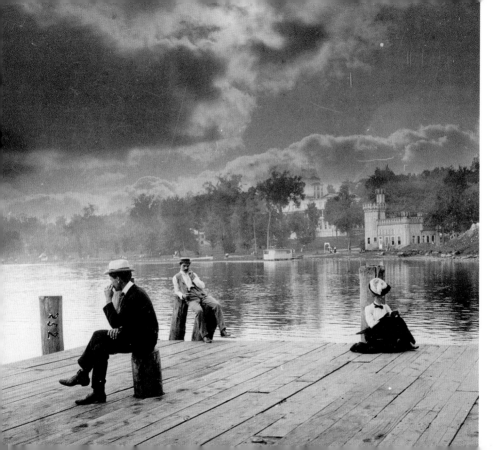

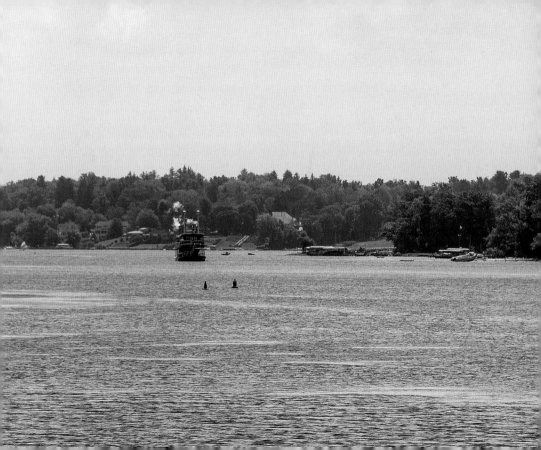

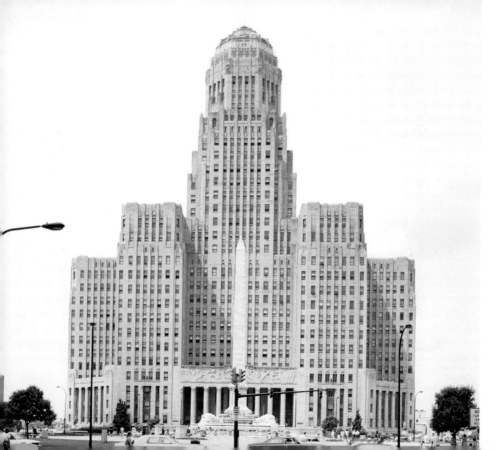

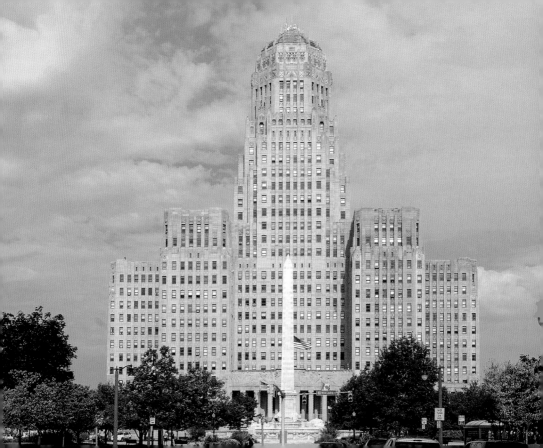

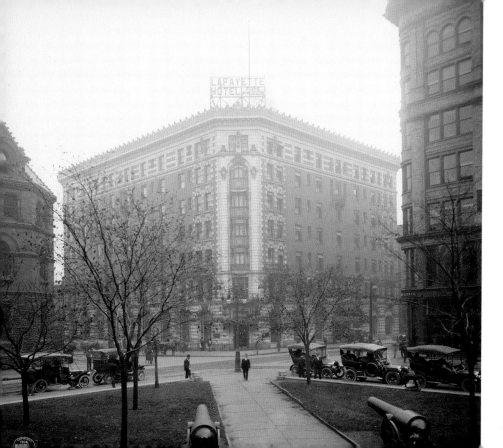

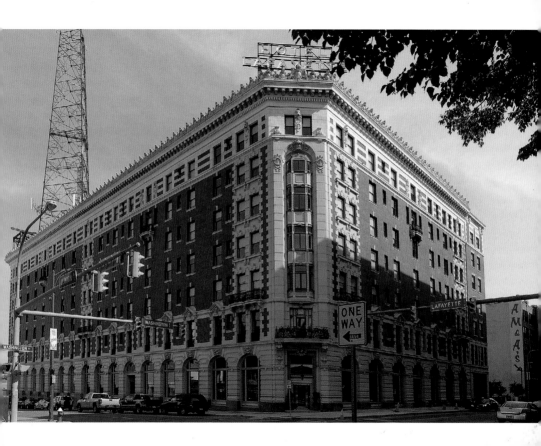

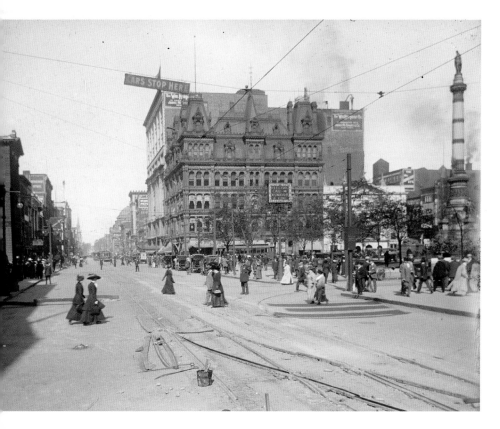

CARS STOP HERE

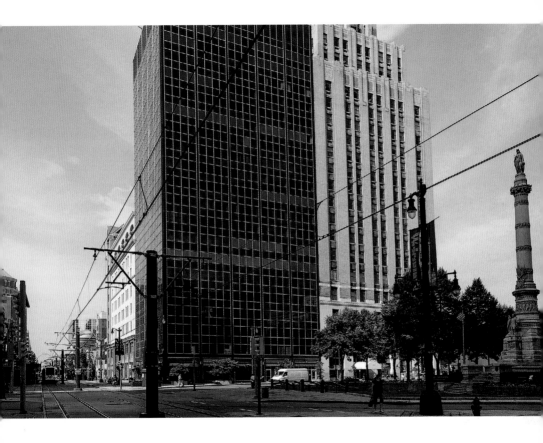

Soldiers' and Sailors' Monument, Lafayette Square, Buffalo, c. 1913

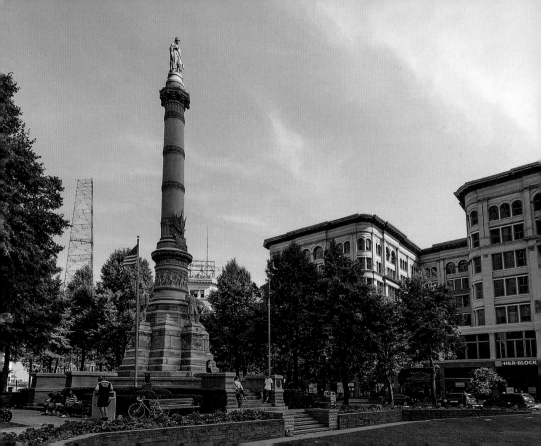

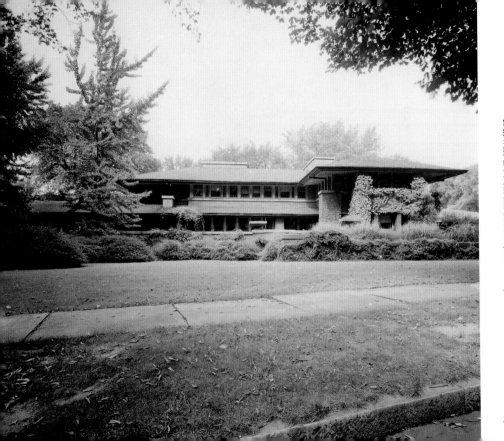

Darwin D. Martin House, Buffalo, 1973

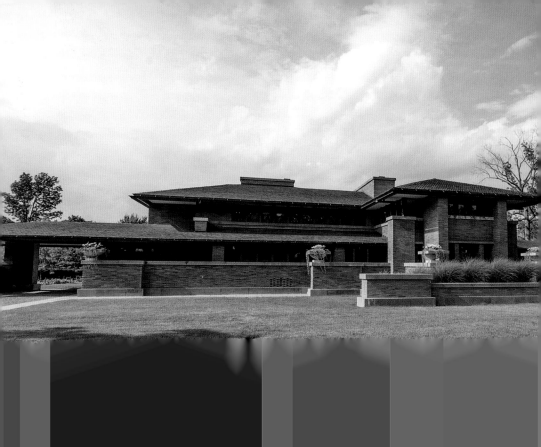

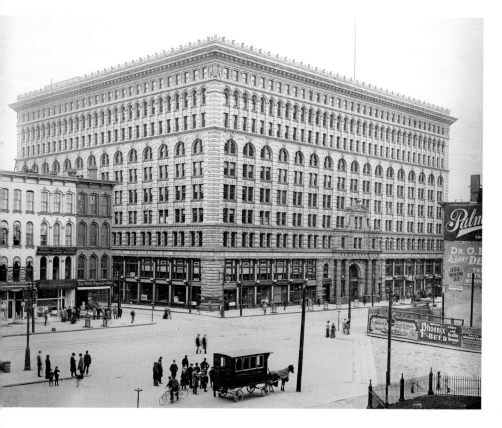

Ellicott Square Building, Buffalo, 1900

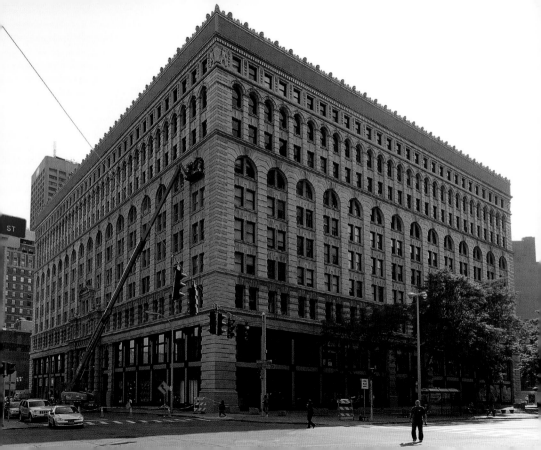

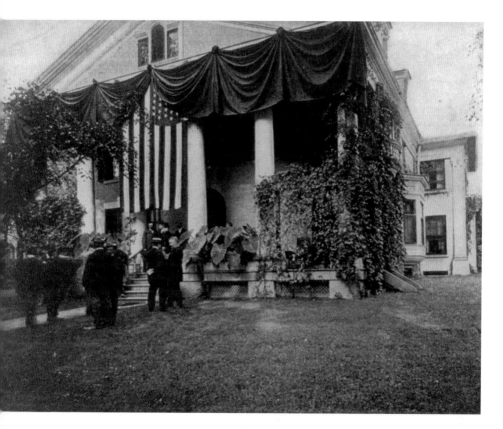

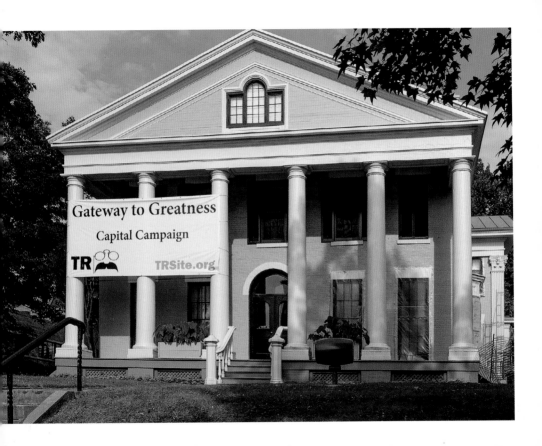

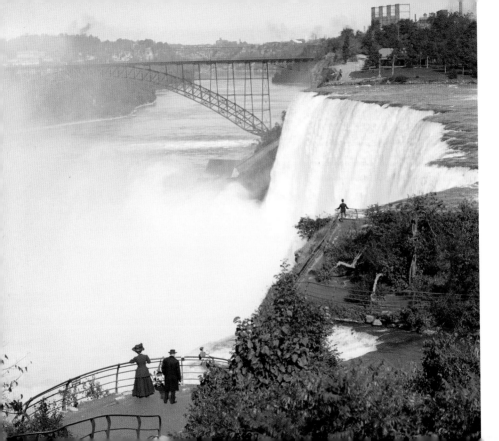

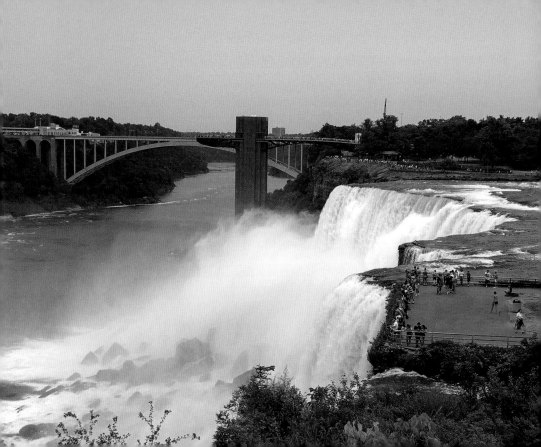

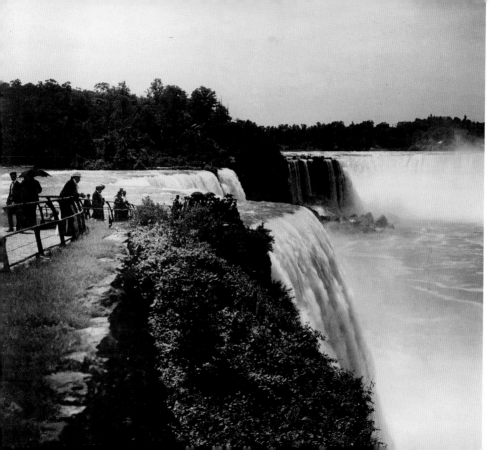

American Falls, Niagara Falls, c. 1910

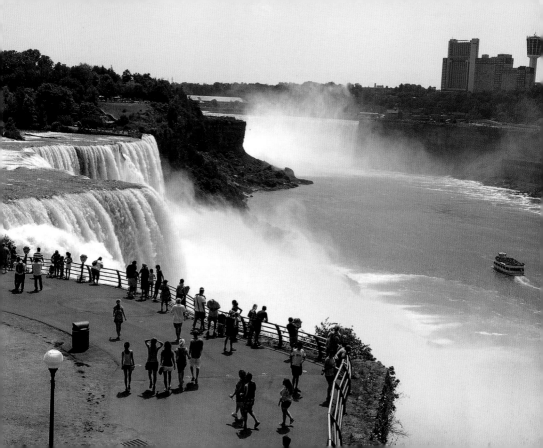

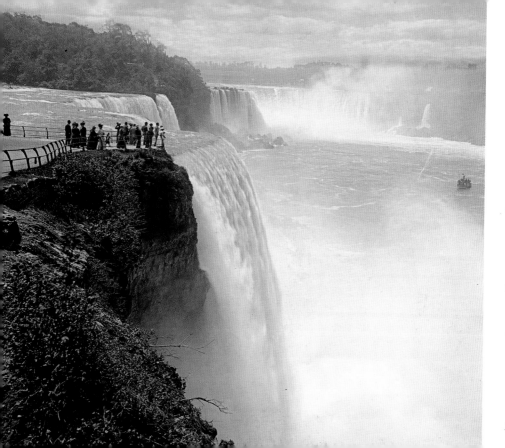

American Falls from Prospect Point, Niagara Falls, c. 1910

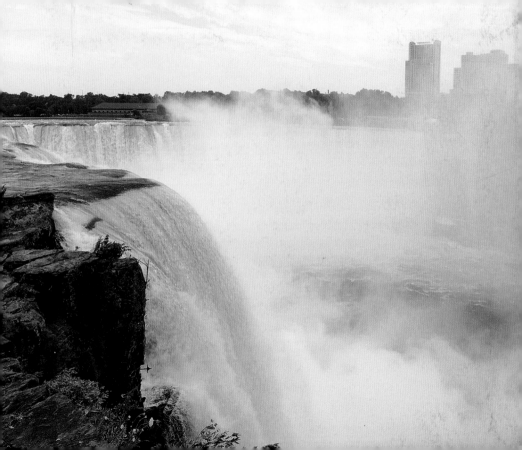

Acknowledgments

All "now" photographs are by David Watts, except for the following:
Paulm27: 13. Jean-Christophe Benoist: 17. Momos: 49. John-Paul
Palescandolo: 51. Chensiyuan: 59. Jim Henderson: 133. Jon Nool: 146–147.
Norbert Nagel: 159. Alamy: 222–223. David Shankbone: 295. Daniel Case:
297. Gryffindor: 301. Dmadeo: 343.

All "then" photographs are courtesy the Library of Congress, except for the
following: Anova Image Library: 30, 38, 44, 94, 100, 118, 149, 150, 154, 156,
162, 198, 212, 232, 233, 242, 286, 288, 290, 292, 332, 334, 336, 338. New
York Historical Society: 54, 76, 312. Corbis: 64, 134, 185, 188–189. NYC
Municipal Archives: 65, 163, 176, 244. NYC Vintage Images: 88, 266, 268,
295. André Robé: 166, 230, 231. Getty Images: 192, 196–197, 230. Rex
Features: 220–221. Alamy: 224–225.

Cover: Broadway and Seventh Avenue at 47th Street, 1959 (Rex Features).
Page 2: New York City street scene by Arthur Rothstein, 1941 (Library of
Congress).

Researched, compiled and edited by David Salmo of Anova Books.